# Havana Street Style

**intellect** Bristol, UK / Chicago, USA

First published in the UK in 2014 by
Intellect, The Mill, Parnall Road, Fishponds, Bristol, BS16 3JG, UK

First published in the USA in 2014 by
Intellect, The University of Chicago Press, 1427 E. 60th Street, Chicago, IL 60637, USA

Series: Street Style
Series ISSN: 2047-0568 (Print), 2047-0576 (Online)
Cover designer and typesetting: Gabriel Solomons
Production manager: Gabriel Solomons
Copy-editing: Emma Rhys
Photo credits and photo copyrights: Martin Tompkins (www.martintompkins.co.uk)

ISBN: 978-1-78320-317-8
E-ISBN: 978-1-78320-318-5

Printed & bound by Gwasg Gomer Cyf / Gomer Press Ltd, UK

**www.intellectbooks.com**

# Havana
# Street Style

By Conner Gorry and Gabriel Solomons
Photography By Martin Tompkins

**intellect** Bristol, UK / Chicago, USA

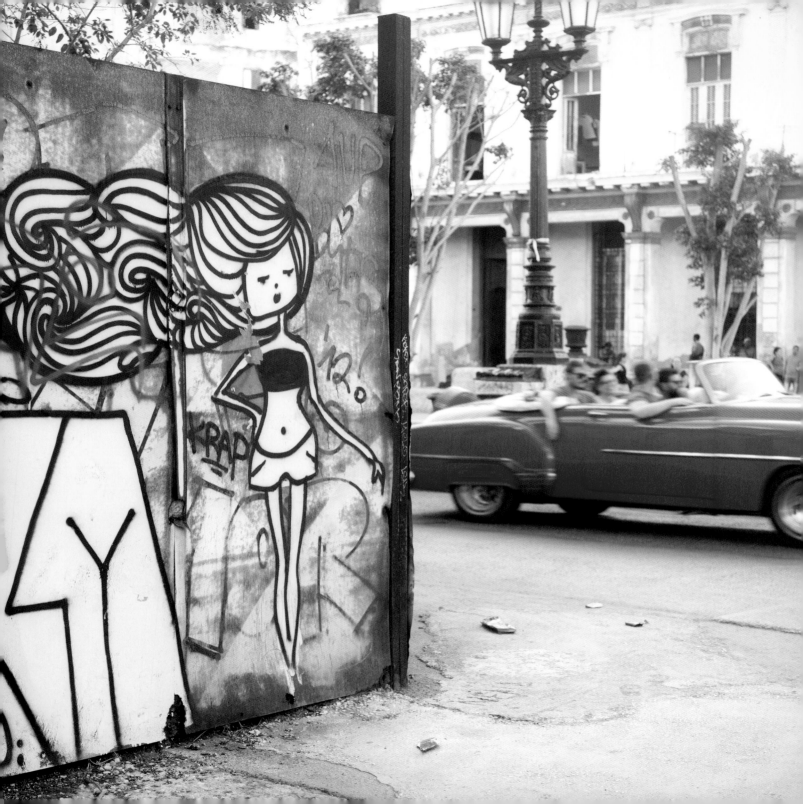

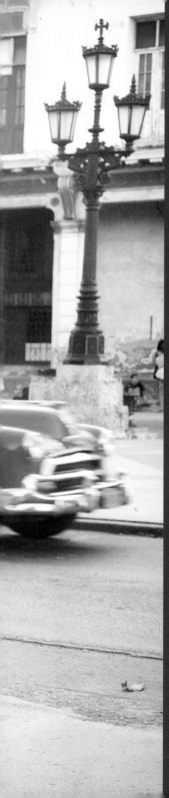

# Contents

Drive-by
Paseo del Prado

**Palm patterns**
Playa

# Acknowledgements

Conner Gorry wishes to thank Douglas Rudd Cairo, Amaya Isla and the entire Cuba Libro community; there is perhaps no better place in Havana to create and write than in the garden at the corner of Calles 24 and 19, Vedado. A heartfelt gracias also to Rodney Ramos, Sandra Herrera, Luis Enrique Carricaburu, Alejandro Jorge Ransoli and co-conspirators Gabriel Solomons and Martin Tompkins.

Gabriel and Martin would like to thank Rosa Maria and Vladimir Rovira for their wonderful hospitality, Ann Marie Stock and Henry Navarro for their invaluable help and advice on all things Cuban, Samuel Riera for his 'on the ground' support and Eduardo Digen for being the best possible 'man in Havana' we could have hoped for.

Our Collective thanks must go to all the fashionable models who agreed to be photographed for this book and to everyone at Intellect for the opportunity to produce a book such as this - which we hope will open people's eyes to the richness, beauty and variety of Havana's burgeoning street style.

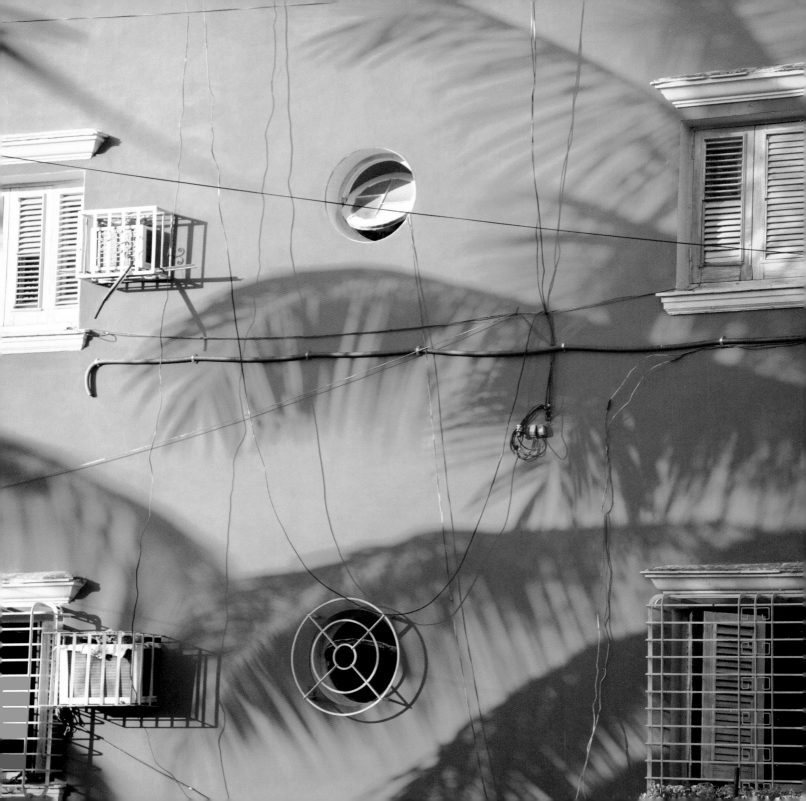

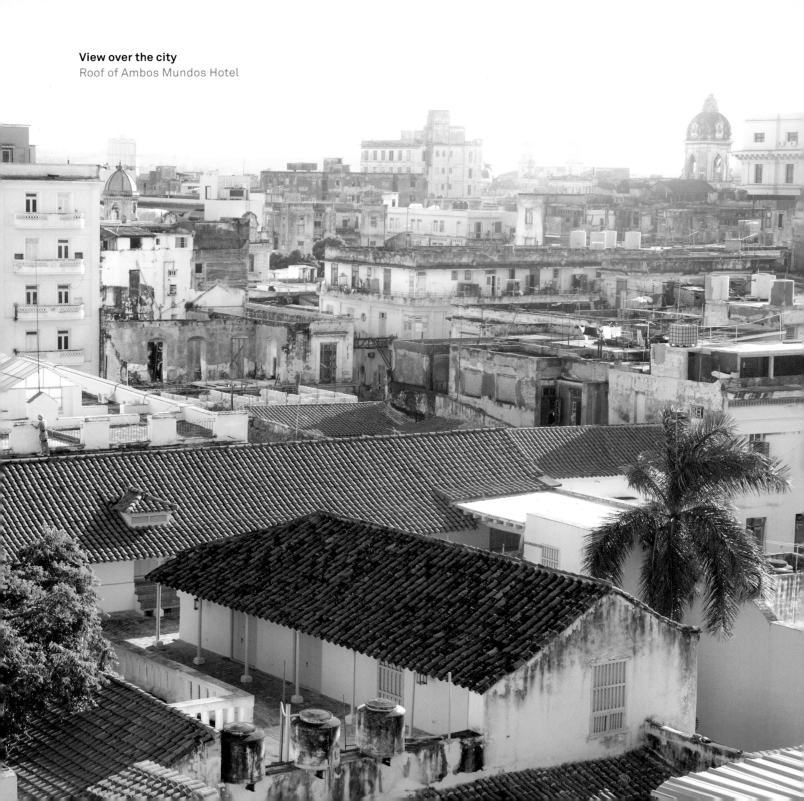

**View over the city**
Roof of Ambos Mundos Hotel

# Foreword
## Henry Navarro

*Ahe, ahe, ahe la chambelona!*
*(hail, hail, hail the lollipop!)*

**When Gabriel Solomons and Conner Gorry** asked me to write the foreword for this book, I was both baffled and exhilarated. The baffled part easily explained because 'street style' does not really register as a concept for a Cuban; for us there is only style and either one has it or not. Still, the scholar in me jumped at the opportunity to provide some historical background to the images and observations you will encounter here. This backdrop would hopefully help readers like yourself gain a better understanding about why twenty-first-century 'Habaneros' dress, beautify, and carry themselves the way they do.

From its humble origins as a trading port villa in the 1500s, Havana's fashion narrative is one of hustling and ingenuity. Early Havana settlers made a living by catering to the fleets going back and forth between Spain and the New World and supplementing this with contraband. Thus, from the beginning Havana Style was dictated by a variety of materials and templates, that were re-combined and adapted to the local mores and needs in a process called 'aplatanar' (literally banana-ing). By the nineteenth century, Havana was the Paris of the Antilles and from its lavish neo-classic balconies, bustles, crinolines, frock coats, and top hats paraded on three lined boulevards. However, their exuberance, bright colors and risqué low cuts made those Victorian looks *aplatanada* versions of similar European styles.

## Foreword

Many of those Colonial motives and sensibilities are still very much alive in contemporary Cuban style, passed along to future generations via the costumes for popular theatre, carnivals, folk music, and Afro-Cuban rituals. Then, yet another influence reached Havana's shores in the twentieth century. Under the United States's economic and cultural influence until the 1950s, the city ended up incorporating some American flair as well. By then Havana's skyline featured tall, modernist buildings and commerce and cultural life moved from Old Havana to El Vedado. Fashion boomed and the couture house Christian Dior had a presence at El Encanto, the largest Cuban department store. However, true Havana style were tropical interpretations of zoot suits, A-line dresses, and wasp waist swimsuits. They became iconic worldwide worn by popular musicians and artists such as Benny More, Celia Cruz, and Candita Quintana. Meanwhile rebellion was brewing in the mountains of Oriente, then the eastern provinces of Cuba.

Young, handsome, and stylish in a proto-hippie way, the rebel army entered Havana in January of 1959 and Cuban style took a revolutionary twist. Both male and female Habaneros integrated fatigues, military boots, and berets into their wardrobes. Eventually the United States embargo settled in and Habaneros had to make do with outdated garments and any fashion imports that reached their shores. However, even during the period of acute scarcity following the collapse of the Socialist Block in the 1990s', Cubans managed to keep stylish by employing the same strategies that have kept their classic American cars on the road; industriousness and wit.

As you will see on the following pages, contemporary Havana style continues to be an integration of sources, concepts, and motives re-adapted to the city's unique character, history and life style. Habaneros borrow both symbolically and literally, from anyone or anything they can get their hands on. All eventually gets *aplatanado* in an unexpected yet very confident manner that has always had a touch of both sensuality and defiance. Somewhere else, Havana style may look outdated, silly, or outrageous. Here, we indeed hail the lollipop. ●

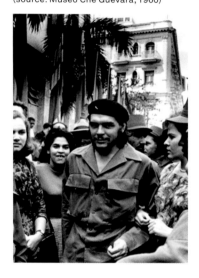

Rebel style: Che Guevara walking through a throng of cameramen down the streets in Havana, with arms linked to his wife Aleida March (source: Museo Che Guevara, 1960)

*HENRY NAVARRO is a Cuban-born multidisciplinary designer, artist, and educator specialized in the practice and theory of contemporary and conceptual fashion. He is best known for exploring current social issues through participatory fashion-based public art projects. Now based in Toronto, Canada, Henry teaches fashion communication courses at Ryerson University.*

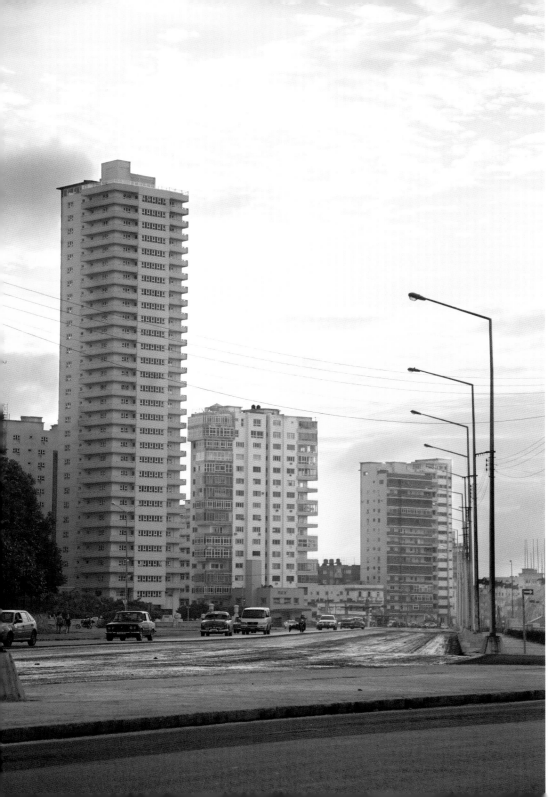

**High rise apartments**
The Malecón

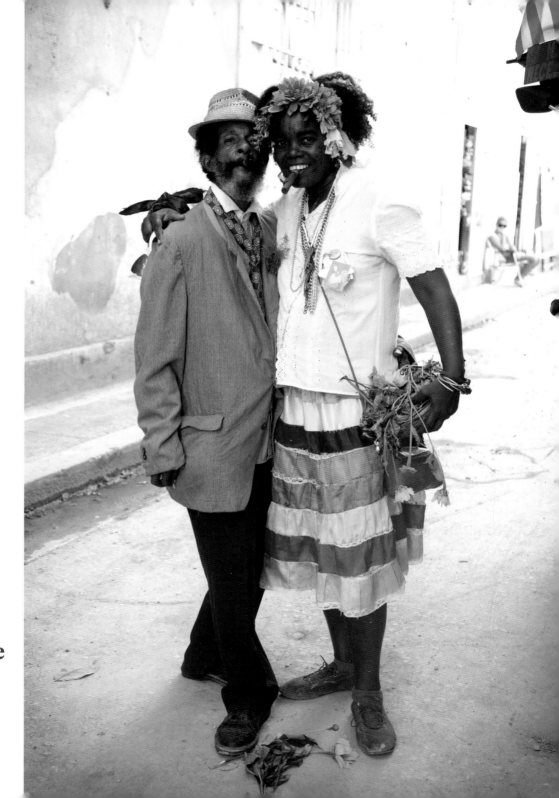

**Complex,
confusing,
frustrating, and
fascinating – the
island has long
been all this...**

# Havana Street Style
## by Conner Gory

→ **Havana is an anomaly, an enigma, a conundrum.**
The place is so confusing, in fact, Cubans say even they can't figure it out. Comedians quip that Cuba is also an onion: The more layers you peel back, the harder you cry. Complex, confusing, frustrating, and fascinating – the island has long been all this, but the rhythm and vibe are becoming even more intense as Cuba undergoes profound economic changes. As you might imagine, the shifting sands are especially noticeable in Havana, the financial, cultural, and political capital of the country. So swift and novel are these changes, impressions from even a handful of years ago are already dated. This is what makes a book like this so valuable: Shot at the tail end of 2013 and written over several months thereafter, it opens the doors to a culture in (r)evolution.

What makes this city so complex? Why are those born and bred here shaking their heads, perplexed by this place? To answer this, we should start at the very beginning, a very good place to start, as Maria instructed the Von Trapp brood in *The Sound of Music* (Robert Wise, 1965).

San Cristóbal de la Habana was formally established in 1519, where El Templete church stands today. Guarded by a sacred ceiba tree (an important symbol in Afro-Cuban religions; more on that later), the first Mass was held on this spot by intrepid Spanish explorers and the Catholic missionaries who accompanied them on their round the world journey. While the tree here today is a replace-

ment, it holds a symbolic place in the heart of Habaneros who make a pilgrimage here each 16 November – the day the city was founded – to make three wishes, one hand on the trunk, walking counterclockwise around the ceiba. It makes a remarkable sight, hundreds of Cubans, dressed for the occasion, waiting patiently, pensively to beseech whoever grants wishes.

These first settlers from Spain were rugged, determined folk; a bit hard-headed they must have been to survive the long, harrowing ocean voyage. Upon arrival, they found a tropical idyll inhabited by indigenous tribes including the Taíno and Siboney. The new arrivals decimated Cuba's original inhabitants, literally working many of them to death; the rest were almost entirely wiped out by imported diseases like smallpox. Just a couple of decades after the first Spaniards arrived, the indigenous population had dwindled to 5,000 and before long, these people would disappear completely. If you observe closely and know what to look for, you can discern traces of these long-gone people in some Cubans' facial characteristics, stature, and customs – especially in the Oriente (eastern) region.

What's strikingly evident, even to casual observers, is Cuba's refreshingly diverse racial spectrum. Some readers may be surprised to find green-eyed, blond Cubans living, working, and playing alongside compatriots as dark as our morning espresso. This is the result of over 300 years of a massive slave trade (Cuba didn't abolish slavery until 1886; the penultimate country in the hemisphere to do so); immigration waves from Spain, France, Haiti, China, and elsewhere; and miscegenation between these groups. This healthy mixture of races, cultures, and traits has resulted in a good-looking, head-turning populace spanning all shades. Centuries of racial intermingling, accompanied by constitutional protections, have – palpably, enviably – tempered racism on the island.[1]

Ask any Cuban about the African influence in Cuba and they'll likely quote the popular aphorism *'quien no tiene de Congo, tiene de Carabalí'* ('who doesn't have the Congo in their blood has Carabalí'). This saying refers to the hundreds of thousands of slaves forced to the island from Congo, southern Nigeria, and elsewhere in Africa, and the racial mixture that ensued. To this day, many words and customs transported across the raging seas in slave ships, adapted and kept alive by people desperate for home and freedom, permeate Cuban life. For instance, *'¿qué bolá, asere?'* is part of Havana's daily vernacular and comes from another continent, another time.

The wellspring of these traditions are the pantheistic, syncretic belief systems known as Afro-Cuban religions, which are autochthonous African beliefs and practices overlaid with Catholic saints and symbols. The most widely ob-

1. Discrimination based on race, skin color, gender and religion is prohibited and punishable by the Constitution of 1976 (Article 42), which guarantees all citizens equal rights under the law. Nevertheless, outlawing racism does not necessarily or immediately translate into the disappearance of racism, since individuals, their bias and perspectives cannot be legislated. In recent years, dedicated educational efforts, media campaigns and academic research into Cuba's approach to discrimination have sought to better understand the tenor of racism in the country, improve policies, and combat bigotry. *Source*: Constitution of the Republic of Cuba, 1976 (as Amended to 2002).

Conner Gorry

Maria, housewife
See pages 32/33

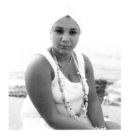

**Ask any Cuban about the African influence in Cuba and they'll likely quote the popular aphorism *'quien no tiene de Congo, tiene de Carabalí'* ('who doesn't have the Congo in their blood has Carabalí').**

served of these religions is known as the Regla de Ocha (or Regla de Lucumí), more commonly referred to as Santería, and is enthusiastically practiced the length and breadth of the island. According to estimates, around 3 million Cubans on the island practice some form of Afro-Cuban religion – including Fidel Castro if the story about him being inducted into the Regla de Ocha religion in Nigeria is to be believed. Everywhere you turn in Havana, you'll see people – adults, children, even infants – wearing the green-and-yellow bracelet known as the *'mano de Orula'*, which signals they've begun initiation into the religion. Let your eyes roam from wrist upwards and you'll see necks draped with *colour-coded* beads corresponding to the wearer's patron saints, known as *orishas* – black and red for Elegguá, red and white for Changó, blue and white for Yemayá and other combinations representing the two dozen or so saints in the Afro-Cuban pantheon. Another common sight is people dressed head-to-toe in white, toting white handbags and umbrellas. These folks are dressed for *Iwayó* – a one-year initiation period for those entering the ranks of Afro-Cuban religions.

The panoply of influences swirling about the island has also forged standards of beauty and fashions particular to its melting pot status. For example, the ideal Cuban woman is pear-shaped, like a Spanish guitar, full-bodied, buxom, and with *carnita* (a little bit of meat) on her bones – diametrically opposed to the wispy waifs glorified by the global movie and modeling industry. Traditional traits including long, dark hair and chocolate-brown eyes are held in high esteem here, as evidenced by the widely reproduced image of the 'Gitana Tropical' (Tropical Gypsy), painted by Victor Manuel in 1929. In Havana, it's not uncommon for women and girls to sport long tresses to their waist. Though bottle blonds (and to a lesser extent, colored contact lenses) are becoming more popular here, it's telling that women dyeing their hair jet black and refusing to cut it into adulthood are customs still followed with gusto.

It would be folly to suggest that Cuba is 'stuck in time' or 'frozen in amber' when it comes to fashion and trends. While it's true that Lycra dies hard, jeans with jean jackets is the unfortunate combo favored during cold fronts, and the lamentable 1980s haircut known as a mullet can still be seen on some men here, Cubans are on the whole, creative innovators and enthusiastic adopters of global styles. Trends seen in music videos and Hollywood – even Bollywood – movies are reproduced and tweaked to suit Cuban tastes and climate. One extravagant appropriation which is steamrolling across the country is the 'yonki', popularized by a *regguetón* singer of the same name who topped the charts with his song and dance dedicated to the hairstyle. Essentially an adaptation of the high top fade popular-

ized by rappers like Doug E. Fresh and Big Daddy Kane back in the day, you can't walk two blocks without seeing a passel of young men sporting this gravity-defying 'do'. The *yonki* is keeping many a barber in business, though they'll be the first to admit it's a ridiculous cut.

One undeniable – unstoppable – influence on all facets of life here, including fashion, comes from the United States. Despite the political and financial isolation the US embargo places on Cuba, the powerful neighbor to the north is seen everywhere, from Ed Hardy to wildly popular Converse sneakers – often cheap imitations, the emblematic star logos sewn on to generic tennis shoes in living rooms from Centro Habana to Cerro. Indeed, Cuba is well-flavored with US elements. This isn't surprising given the centuries of shared scientific, cultural, and educational ties between the two countries. Prior to the triumph of the revolution, people – well-to-do people, let there be no doubt – passed seamlessly between the United States and the island. Back then, Cubans who could afford it went north for university and professional degrees. Dr Carlos Finlay, the scientist who discovered the cause of yellow fever (saving innumerable lives in the process), received his medical training in the United States; musicians like Nat King Cole, Cab Calloway, and Sarah Vaughan played regularly in Havana's hottest clubs and cabarets; and US architectural firms designed the Hotel Nacional and ironically, the bully of a building housing the US Interests Section. Of course, policies between the two – especially during the Cold War – curtailed this synergy, but more progressive travel legislation on both sides of the straits, coupled with the digital explosion which is facilitating the transfer of media and news to the island, is fueling a new, invigorated interchange.

While there are no Coke billboards, beer ads or TV spots peddling soap (an unexpected delight for first-time visitors) the freer flow of information and people – particularly family members visiting from Miami, Madrid, and other foreign latitudes – means Cubans are savvier about, and in tune with, global trends and tendencies than you might expect. Considering there's no MTV or YouTube, Spotify or iTunes in Cuba,[2] it can be startling just how plugged in many people are here. To wit, during their semi-stealth visit to Havana in April 2013, Beyoncé and Jay-Z were so thronged by adoring fans they required bodyguards and a police presence. Give these pages a brief leaf through and you'll appreciate this contemporaneity: Rihanna, Chris Brown, 50 Cent, and Marc Anthony were among the fashion inspirations cited by people interviewed and photographed for this book. Cubans keep on top of the global cultural Zeitgeist through digital media passed hand-to-hand like a bottle of rum on the Malecón; pirated TV shows, movies, and concerts sold everywhere for 1 CUC$ (complemented by those shown on state tel-

2. Internet use in Cuba is often misrepresented and misunderstood. While the dial-up connection is an unbelievably slow 46kbps (on a good day) and, according to the World Bank, only 25 per 100 Cubans officially have an in-home connection, these facts mask the realities. (It's also worth noting that between 2009 and 2012, this number has nearly doubled). Some people have connections at work - fast enough for streaming even - and those Cubans with in-home Internet share and re-sell their connection. So while usage is still low relative to where you live, it's not as low as generally reported.

**Conner Gorry**

evision); and people bringing in magazines and other media in their luggage.

Historically, the flow of Cuban culture from here to everywhere else has been less robust, the massively reproduced image of Che Guevara (who wasn't Cuban and only lived for about a decade on the island) looking intensely into the middle distance notwithstanding. This changed dramatically in 1998 when Ry Cooder's *Buena Vista Social Club* project garnered a Grammy award. This was followed by the Oscar-nominated Wim Wenders documentary about the musical convergence between Cooder and this group of Cuban *son* elders. The recording and film took the world by storm, introducing Cuba's traditional music to listeners around the globe. More importantly, the Buena Vista Social Club phenomenon pulled back the curtain on the 'forbidden island' where large-scale international tourism wasn't officially sanctioned until the mid-1990s; under the US embargo, people from the United States still can't travel freely to Cuba – another pleasant surprise for many visitors. Suddenly, the intoxicating cocktail known as a mojito, was exhausting bartenders from LA to Lisbon (this iconic Cuban drink made from rum, crushed mint, sparkling water, lemon, and Angostura bitters is time consuming and labor intensive to mix) and young hipsters began sporting *guayaberas* – Cuba's classic dress shirt.

All male readers should take a moment here to give thanks for the *guayabera*: Invented over two centuries ago in Cuba (or so the legend goes), it negates the need to ever wear a necktie in the tropics. Indeed, spotting a Cuban in a jacket and tie is as rare as walking through Havana Vieja without being offered black market cigars. The *guayabera* is the perfect solution for our climate and context; it's light, it's loose, and it camouflages pot bellies beautifully. It's also simple: Either short-sleeved or long, it's made of cotton or linen, and has a boxy cut adorned by four pockets and two bands of horizontal pleats running from collarbone to waist. The *guayabera* has completely supplanted the need for a suit and tie and is considered formal wear for even the most elegant and official affairs, including those at the highest levels of government. The current president, Raúl Castro, is often seen in a *guayabera*, for instance, and City Historian Dr Eusebio Leal Spengler – the man behind Havana Vieja's gorgeously ambitious restoration – is nearly always seen in public sporting his characteristic grey *guayabera*. There's even a *guayabera* museum in Sanctí Spíritus with 200 or so examples, including one from Gabriel García Marquez's personal collection. Like a fine Cohiba cigar, a sky-scraping royal palm, or a pristine white-sand beach dotted with the most beautiful women (and men) eyes have ever seen, the *guayabera* is an enduring Cuban symbol and one of the few endemic fashions gone global.

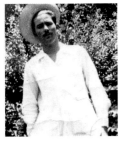

Ifrain Caraballoso Iglesias wearing a *guayarbera* in 1952. Photo by Ifrain (wikicommons)

# Like a fine Cohiba cigar or a sky-scraping royal palm, the *guayabera* is an enduring Cuban symbol and one of the few endemic fashions to have gone global.

For all the outside influences and scant domestic manufacturing, Cubans are not fashion copycats – they appreciate, appropriate, and then adapt, rather than simply adopt. Master seamstresses and tailors pepper Havana from El Cerro to Marianao, Miramar to Regla. These men and women do more than just sew: They combine design, tailoring, and problem-solving skills to render their finished products more art than service, more innovation than alteration. A survival strategy honed over decades of scarcity, sewing and repurposing (of everything, including clothing), were taken to new heights during Cuba's economic crash known as the Special Period.

Beginning in the early 1990s, the dissolution of the Soviet Union and Socialist Bloc hit everyone – men, women, children, the state – hard, as Cuba lost close to 85 per cent of its aid and trade faster than you can say 'perestroika'. The effects on daily life were sweeping and traumatic: Sixteen-hour blackouts meant no ice, cold water, fans, or air conditioning – a real challenge in Cuba's blistering heat; public transport ground to a halt, motivating the importation of 1 million Chinese bicycles and rapid improvisation of bike lanes; and adults' daily caloric intake fell by 33 per cent. Such economic hardship reinforced and invigorated the

culture of re-using, recycling and repurposing anything and everything that may have a future use.[3] *Granma*, the daily newspaper, was cut into toilet paper-sized squares to be used for that express purpose; wine was fashioned out of anything fermentable including guava, pineapple, and rice; and cats were called 'rooftop rabbits' since they tasted similar. Cubans, who seem to feel solidarity in their bones, stepped up for friends, family, and neighbors, sharing everything from socks and shoes, to sheets and underwear.

These harrowing years left their mark, however, sticking in the Cuban psyche like a shred of meat in a molar. Bike riding, for example, carries heavy stigma still, enduring as a symbol of hard times. 'Ride a bike? *¡Hombre no!*' folks will say. 'Do you know how far and long I had to ride a bike to get to work during the Special Period? Never again' (personal communication). And the stories of food insecurity (i.e. hunger) are legendary. Ask any Cuban old enough to remember the Very Special Period as we sometimes call it, and they'll have tales of eating *'pasta de oca'*, a mystery meat containing more mystery than meat; raising government-distributed chicks on their balcony with the hopes they would survive to see them on a dinner plate; and if/when that failed, frying up breaded grapefruit peels. This

3. The years prior to this, when Cuba was safely hitched to the USSR's star, are remembered with dewy-eyed nostalgia by Cubans 40 and older. Ask around and you'll fast learn that these are considered the country's halcyon days, when Cubans honeymooned at the Habana Libre, the peso had enough purchasing power for nights out on the town, or buying personal and luxury items with which the stores were stocked, and you could make ends meet on your state salary. During this time, Cubans had let their thrift and parsimony slip into a stupor; this all changed with the fall of the Berlin Wall.

last may be urban myth, (as the tales of shredded condoms standing in for pizza cheese surely are), but you get the picture: Nothing was easy and the privation of those years isn't easy to forget. 'Many times it's not actual hunger people are feeling these days: It's psychological hunger, carried over from when there was so little to eat,' observes historian Fernando Martínez Heredia (personal communication). If you've ever seen Cubans enjoying themselves at a resort buffet, you've witnessed this psychological hunger first hand. Although times have improved, things are still hard for (too) many people and the custom of altering clothes, swapping outfits and accessories among friends, and repairing shoes which otherwise would be sent to the trash can, remains strong.

Taking a look through this book begs the question: Where do Cubans get their clothes, after all? How can they be as fashion forward as they are when there isn't an Abercrombie, H&M, or El Corte Inglés to be found on the island? True, there are government-run clothing stores, private boutiques, and name-brand outlets including Mango and Adidas, but the limited selection and high prices put these out of reach of most. This doesn't prevent Cubans from striving to look good and well put together whenever they step out, however – a powerful cultural trait many a chagrined tourist in shorts has discovered. The main source of fashions, of course, is the same as the main source of hard currency: Family living abroad. They know better than most how hard things are on the island and how difficult it is to procure new, stylish clothes. As a result, they'll send or bring back bags bursting with Lacoste shirts, Crocs (still all the rage here), jeans, and Lycra. What doesn't fit or isn't to the recipient's liking will be altered, traded, or sold.

Cubans residing on the island who travel abroad are another source. Certain countries – Haiti, Honduras, Ecuador – are fertile ground for cheap clothing and these travelers do a brisk business selling it upon their return. Technically it's illegal, a part of the internal market that's more gray than black. As this is being written, women are making the rounds of businesses and offices peddling pants, shoes, blouses, and if you're lucky, bras in the right size. Just yesterday, one such re-seller came by with polka-dotted polyester leggings. The price tag? Fifteen dollars. The government also administers a network of second-hand clothing shops – state-sponsored thrift stores, if you will – where clothes hang limply on hangars or are piled in mountains on the floor for picking through. Known as *'trapi-shoping'* or 'rag shopping', there are some finds for the patient few who enjoy picking through those mountains.

For the more discerning, there are artisan dressmakers and designers who have stalls at Havana's biggest markets. The massive Almacén de San José,

**Conner Gorry**

where Old Havana meets the Bay, is packed with crocheted miniskirts and dresses, tie-dyed tank tops, and of course, *guayaberas*. Head to the market at Malecón and Calle D and you can choose from dozens of original, stylish shoe designs, all handmade in Cuba. A few private clothing shops have cropped up too, Jacqueline Fumero's chic boutique in Havana Vieja being a standout. All of these strategies for procuring threads mean Havana style is eclectic and malleable. No matter the person, occasion, or time of day, you'll find Cubans rocking a sporty, bohemian, vamp, or hipster look.

One interesting paradox vis-à-vis Cubans and fashion trends is that no matter how long it takes a fad or style to arrive on these shores, people are as quick to discard them and move on as they are to appropriate and adapt. Several recent fads, including anything from wallets and purses to shoes and shirts emblazoned with the Union Jack, and gold teeth, fall squarely into this 'super hot' and then 'definitely not' category. Clearly, some fashion stylings are so classic, iconic or practical (at least to those sporting them) that they never go out of style; in Havana, neon colors, short and tight anything, and sky-high heels are always workable options. Tattoos, a very underground, fairly rebellious fashion statement just a decade ago, are all the rage here now and seem to only get more popular with time. The fashion landscape gets more complicated, however, when the items or style desired require scarce resources; unsustainable and expensive (for here) looks include breast augmentation, for which you have to supply your own implants; acrylic nails requiring regular maintenance; and hair relaxers or 'perms' as these chemical treatments for kinky hair are known. These last are especially desired by Cubans – men and women – of color since there are few imported products which do the trick and no domestic manufacturers filling the demand.

The Havana you'll see in these pages are a snapshot of a culture in the midst of a sea change: Things are evolving so fast in Cuba, it's doubtful things will look nearly the same in two years time. Already this alteration is underway: Whereas a couple of years ago you'd be lucky to find a Rápido (Cuba's fast-food chain) open after 11 p.m., today there are innumerable cafeterias, clubs, lounges, and high-end restaurants catering to the late-night crowd. Sushi, Russian, and Swedish dining, designer accessory stores, and even pet-clothing boutiques are among Havana's offerings, providing a heretofore unimagined array of choice to the city's inhabitants. Only time will tell how long these new businesses will survive – we've already watched as many a promising store or restaurant opened and closed – but one thing is certain: Cubans will forever do whatever is within their power to dress with thought and panache. ●

Rodney, DJ/BMX stunt rider
See pages 102/103

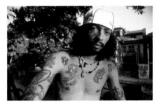

**Tattoos, a very underground, fairly rebellious fashion statement just a decade ago, are all the rage here now and seem to only get more popular with time.**

**References**

Anon. (2013), 'Police are called to keep Beyoncé and Jay-Z safe in Cuba as they are mobbed by fans while eating in Havana', *Daily Mail*, 5 April.

Constitution of the Republic of Cuba, 1976 (as Amended to 2002), Art. 42, Havana, Cuba.

Frank, M. and Reed, G. (1997), 'Denial of food and medicine: The impact of the U.S. embargo on health and nutrition in Cuba', Washington DC: American Association for Public Health.

Lowinger, R. and Fox, O. (2005), *Tropicana Nights: The Life and Times of the Legendary Cuban Nightclub*, Orlando, FL: Harcourt.

Sainsbury, B. and Waterson, L. (2013), *Cuba*, 7th edn, Melbourne, Australia: Lonely Planet.

World Bank (2012), *Internet users (per 100 people)*, Washington DC: World Bank.

**Cocotaxi**
Lennon Park, Vedado

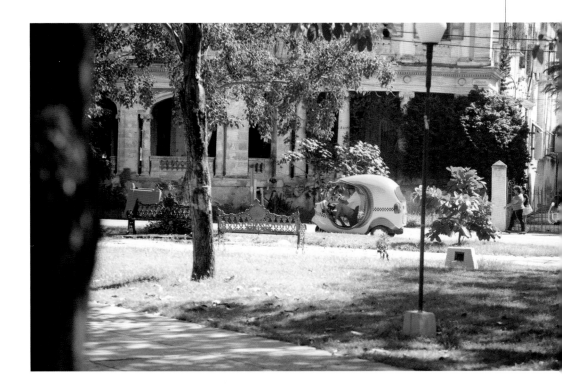

'No matter how long it takes a fad or style to arrive on these shores, people are as quick to discard them and move on as they are to appropriate and adapt.'

**Havana Street Style** Conner Gorry →

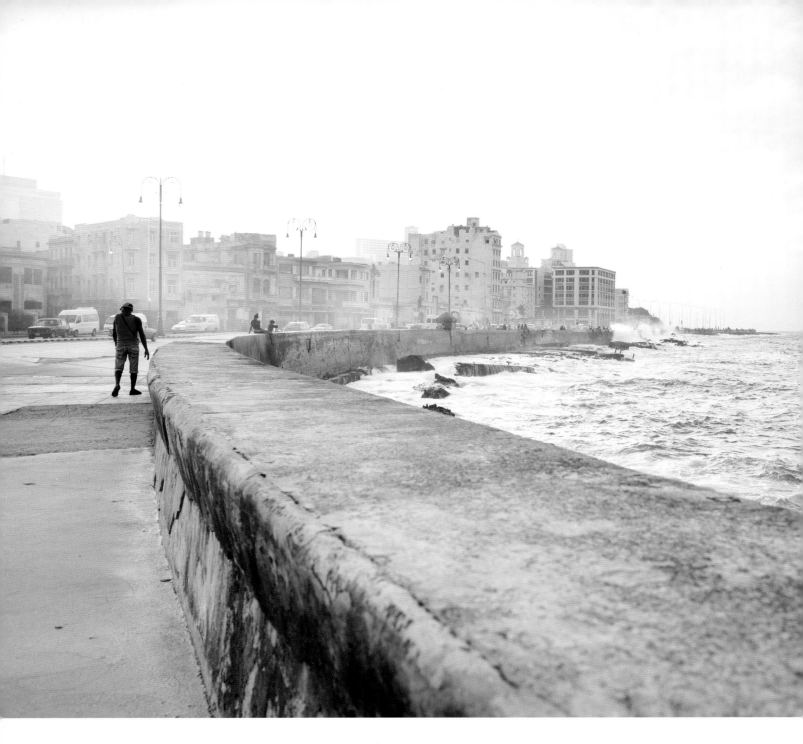

# The Malecón

Paris has the Eiffel Tower, Manhattan the Empire State Building, and Rio de Janeiro Copacabana Beach. Havana iconic, meanwhile, is defined, bounded, and exemplified by the Malecón, the city's emblematic 5 kilometer-long seawall. The most proletariat of monuments, Habaneros of every ilk and class flock to the Malecón to lounge, neck, complain, dance, and dream. No matter from where you hail or how long you've been away, a stroll along the seaside promenade is obligatory, as much for the physical landscapes as the superlative people watching.

Begun in 1901, it took over 50 years to build the Malecón, which serves as both metaphor and means for the city's inhabitants: it is the last frontier between the island's shores and the promise of a different life *más allá*, while also providing a respite from Havana's stifling heat and the opportunity to meet friends, hustle tourists, and scheme escape. The wall traverses the city's major residential neighborhoods, starting in historic Habana Vieja in the east, before segueing into gritty Centro Habana and passing through pastoral Vedado to the west. It ends rather abruptly just before the tunnel leading into upscale Miramar. The honeyed light of a Caribbean sunset is best appreciated from a perch anywhere along the world-famous wall - except for the several blocks facing the US Interests Section, the ersatz 'enemy' embassy, where stopping, fishing, swimming or sitting is strictly prohibited.

The Malecón is as much parade ground as meeting hall and sitting a spell on its wide, cement berth will enchant with the mosaic of Havana humanity strutting their stuff - as much for their own delight as that of others. On any given day or night, you'll see folks dressed head-to-toe in white, for example, which is a rite of passage for those entering the ranks of Afro-Cuban religions (colloquially known as Santería). These people are *haciendo santo* in local lexicon and this attire is known as dressing for *lwayó*. If they're out after dark they're – technically - required to have their white umbrella open and held aloft, one of the many rules accompanying this initiate stage of their belief. When you see someone dressed for *lwayó*, take a close look at their beaded necklaces; what colors they wear signify to which saints they belong. Couples dressed in matching outfits; children decked out in what could pass for cabaret wear; closely-shaved metrosexuals; sophisticated gents in two-toned shoes and fedoras; and little old ladies in genuine vintage: spend an hour or two watching Havana cruise the Malecón and you'll be delighted with the quality and variety of how *capitalinos* choose to express and dress themselves. The super observant may even pick up a creative fashion idea or three while they're at it.

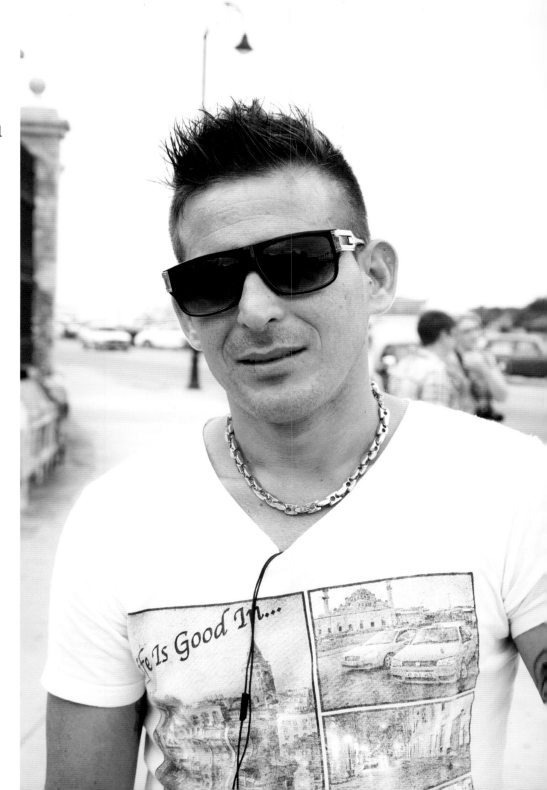

'my style is a cross between punk and rap. I designed the shoes myself.'
— JORGE LUIS

Jorge Luis (32)
Tattoo artist

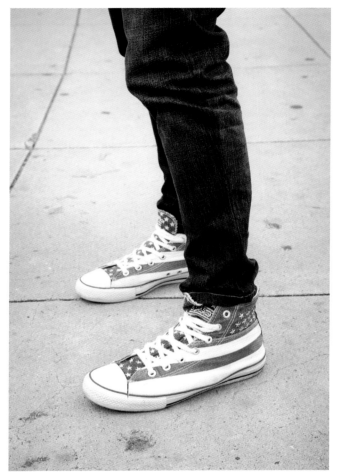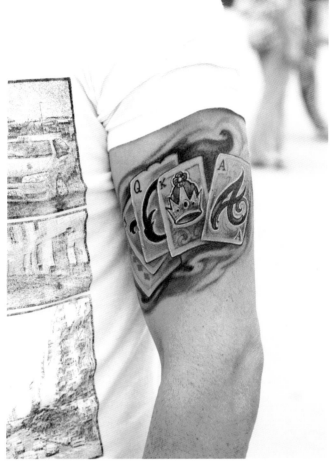

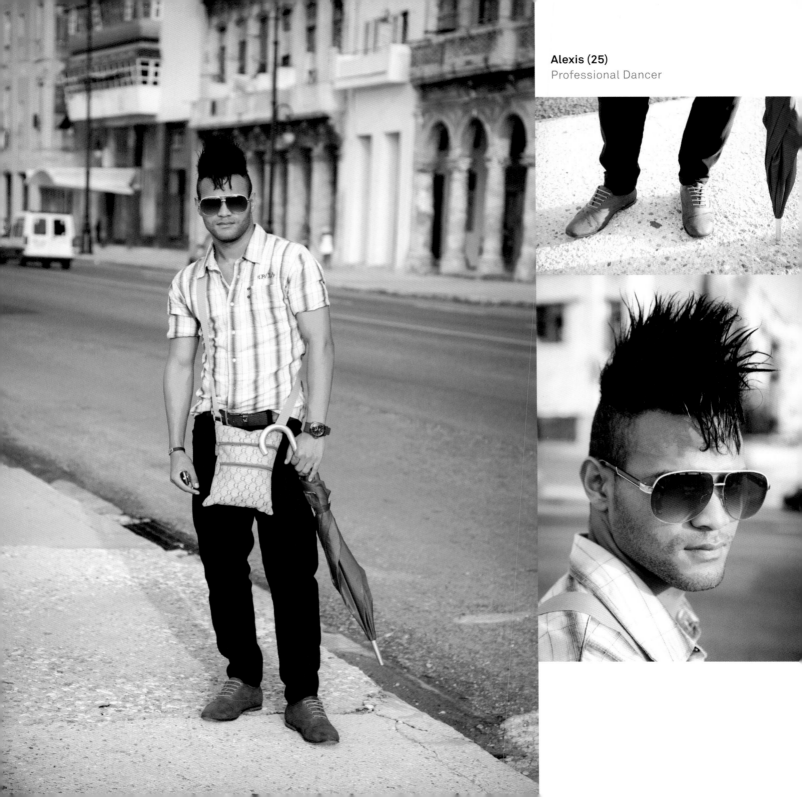

**Alexis (25)**
Professional Dancer

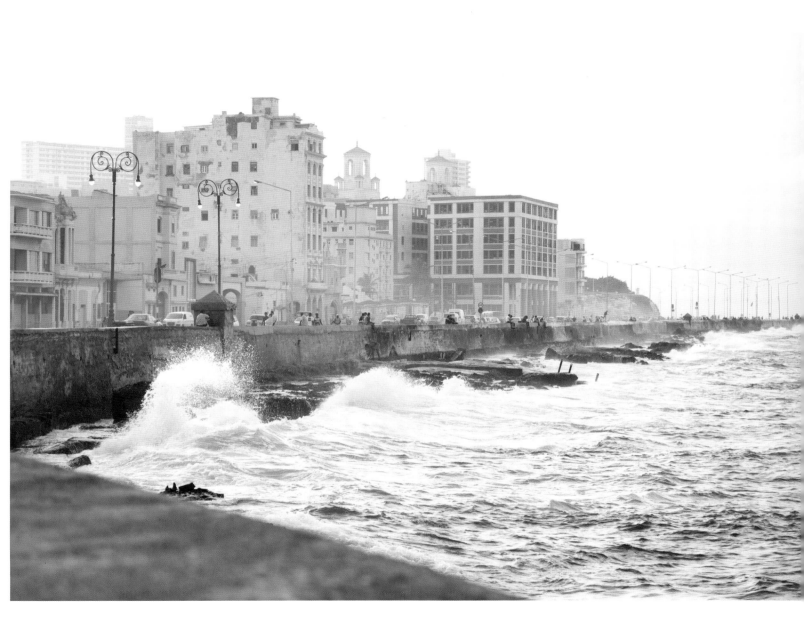

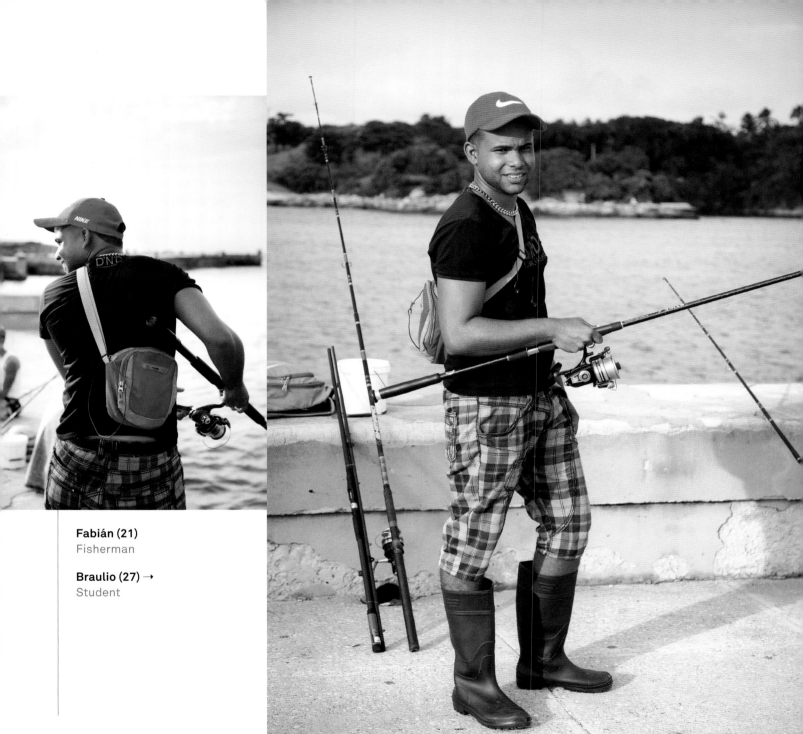

**Fabián (21)**
Fisherman

**Braulio (27)** →
Student

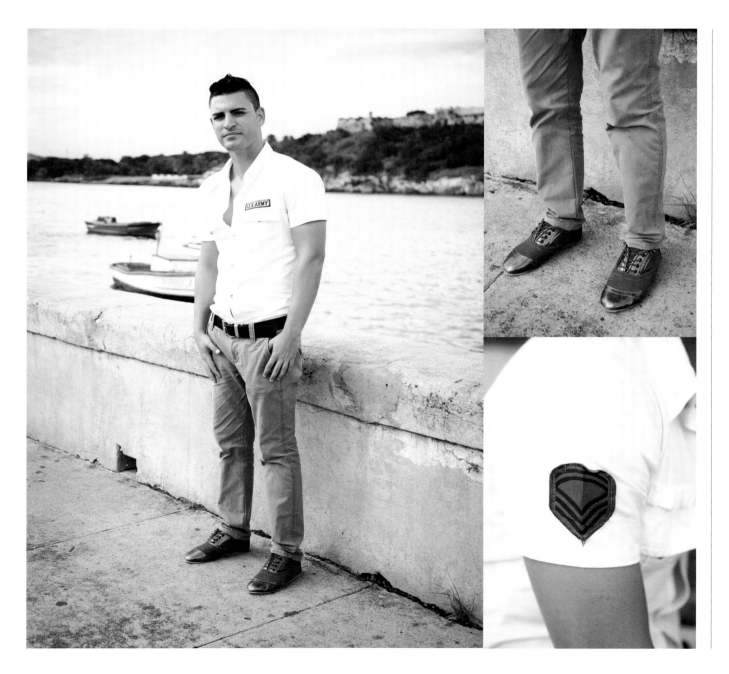

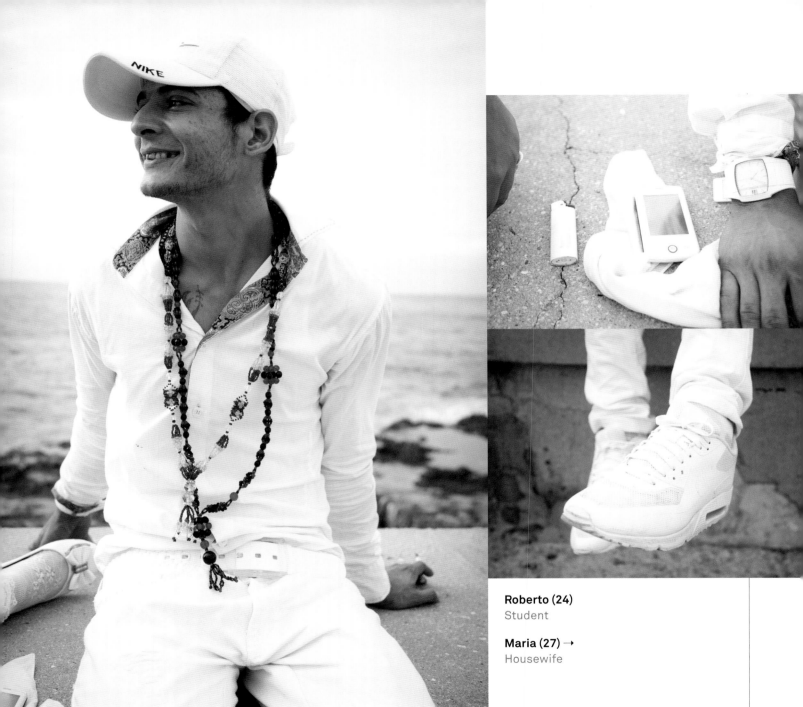

**Roberto (24)**
Student

**Maria (27) →**
Housewife

32

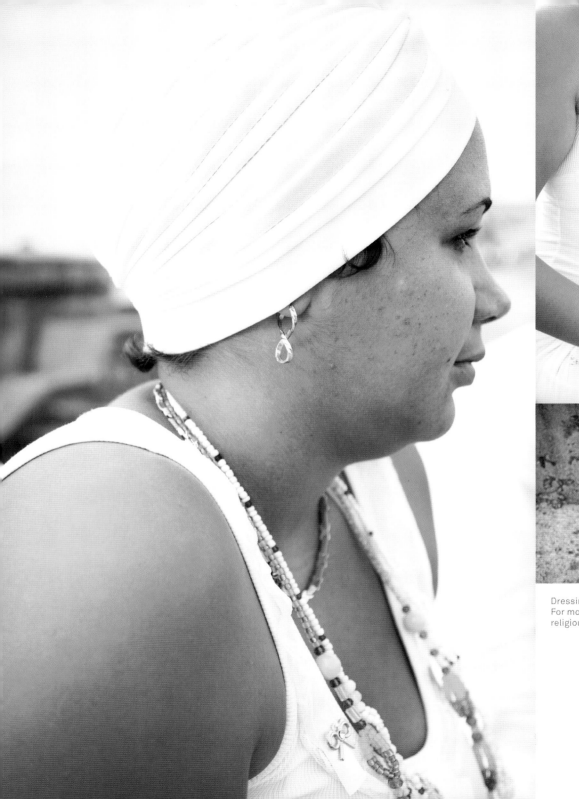
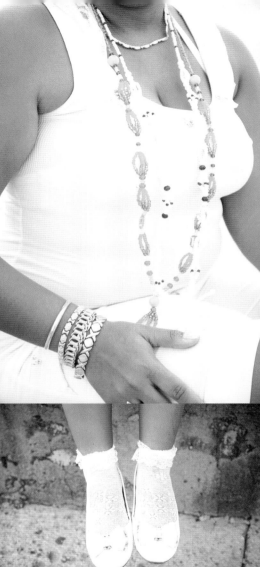

Dressing for *Iwayó*.
For more about this Afro-Cuban
religious fashion see page 25.

**Yuniel (27)**
Bus Driver

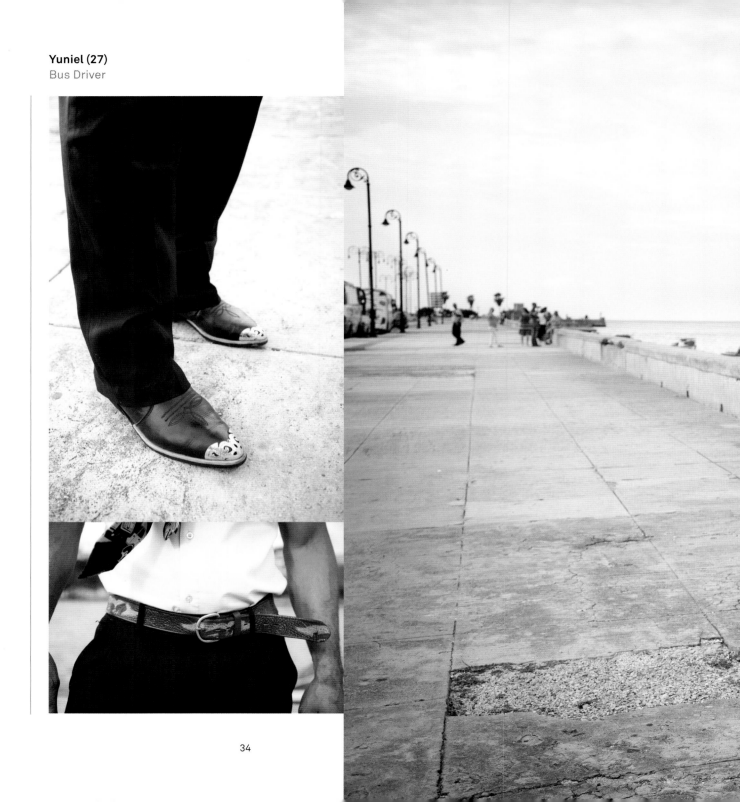

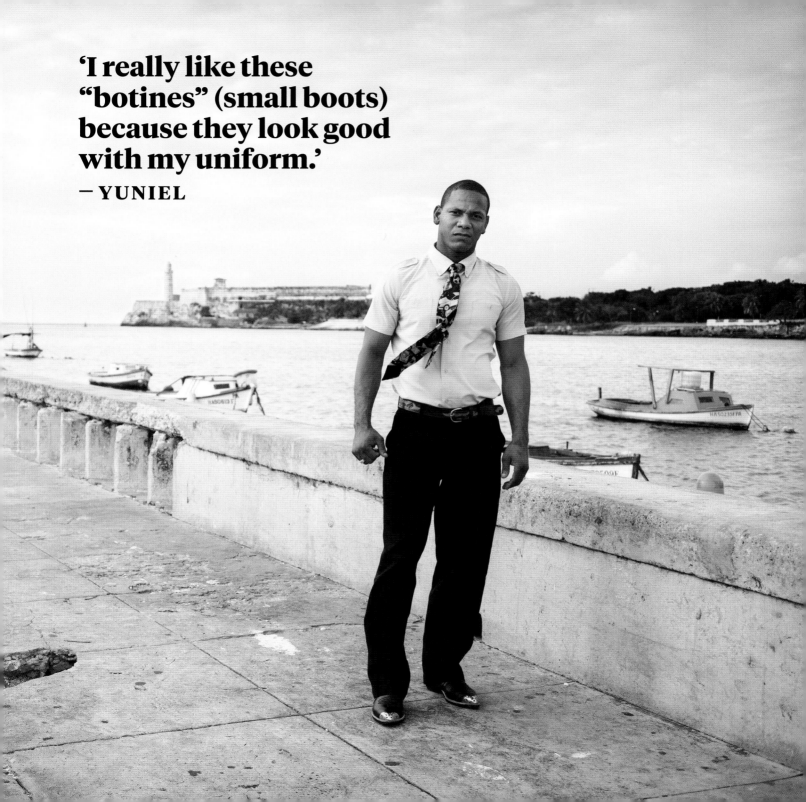

'I really like these
"botines" (small boots)
because they look good
with my uniform.'
— YUNIEL

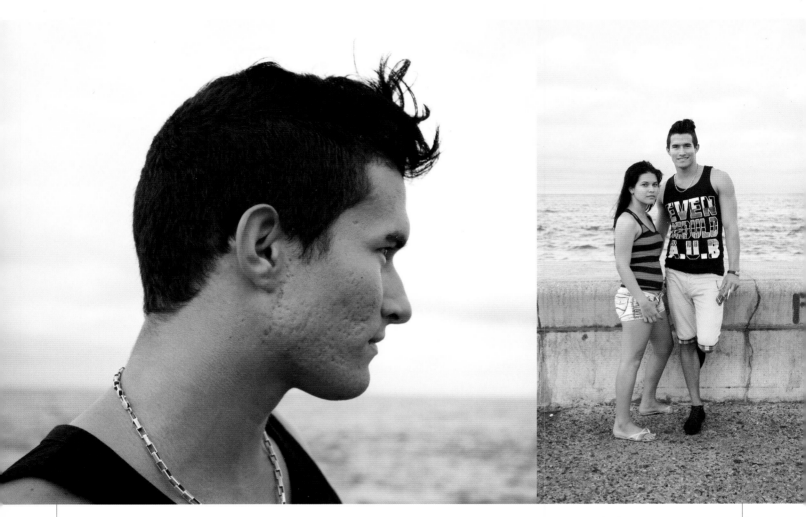

**Magdiel (19)**
Economics student

**Geydis (16)**
High school student

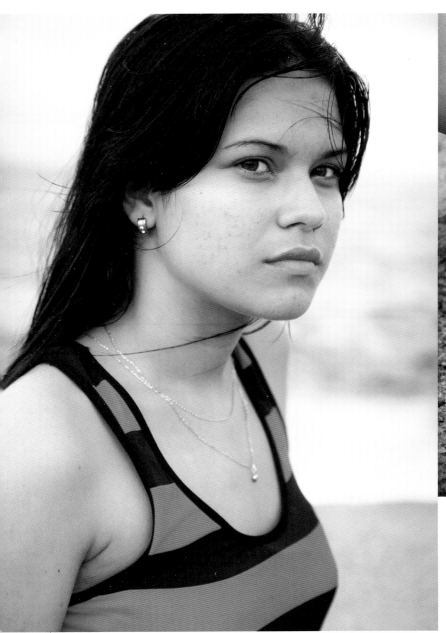
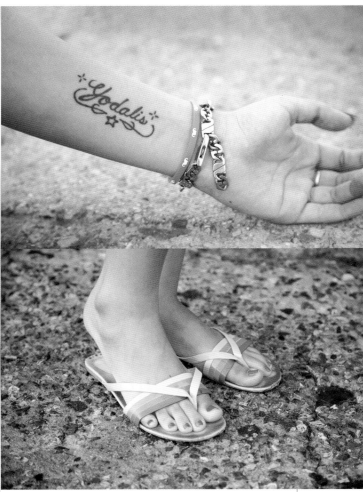

**Juan Carlos (29)**
Mechanic

**Damiens (20)** →
Public Health worker

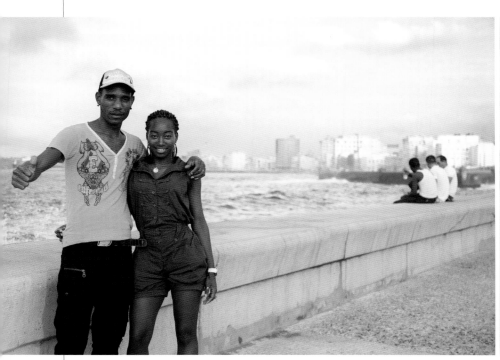 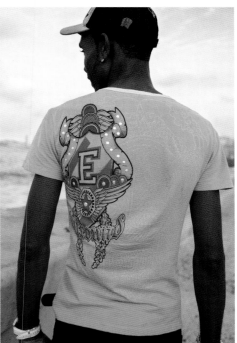

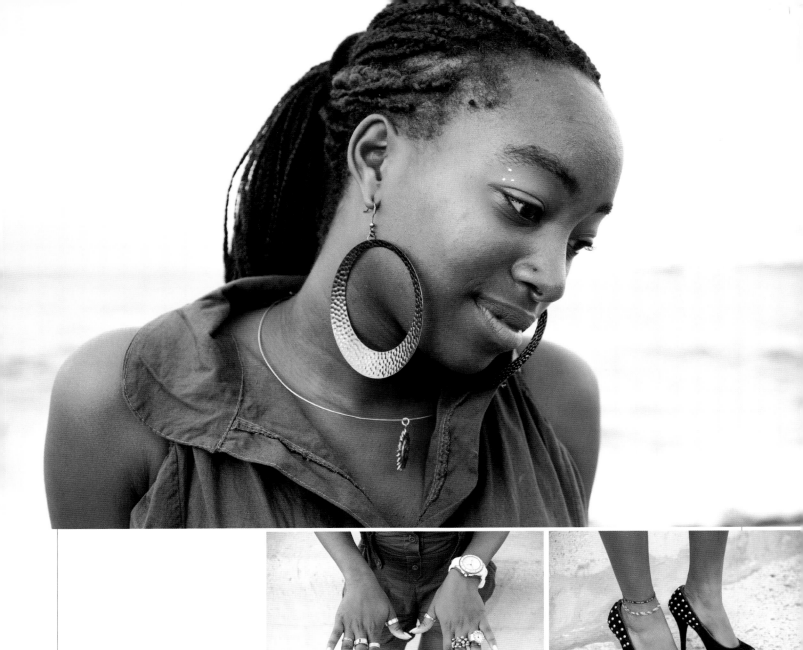

**Yosmani (22)**
Student

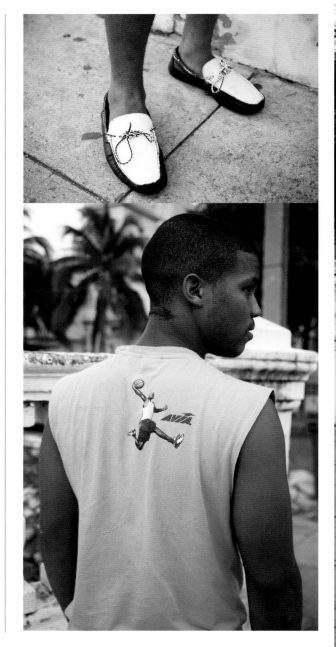

40

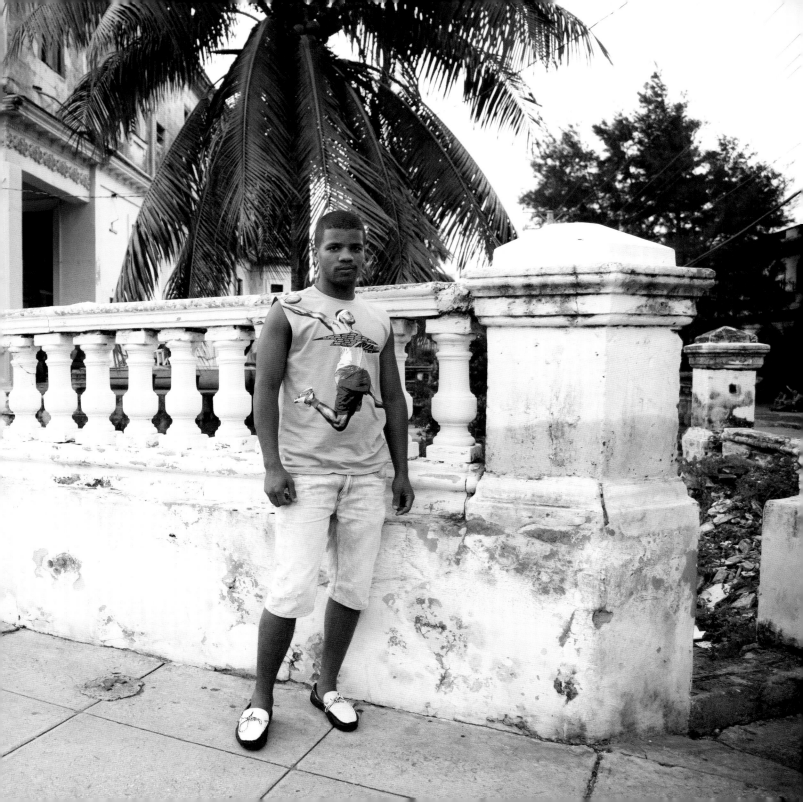

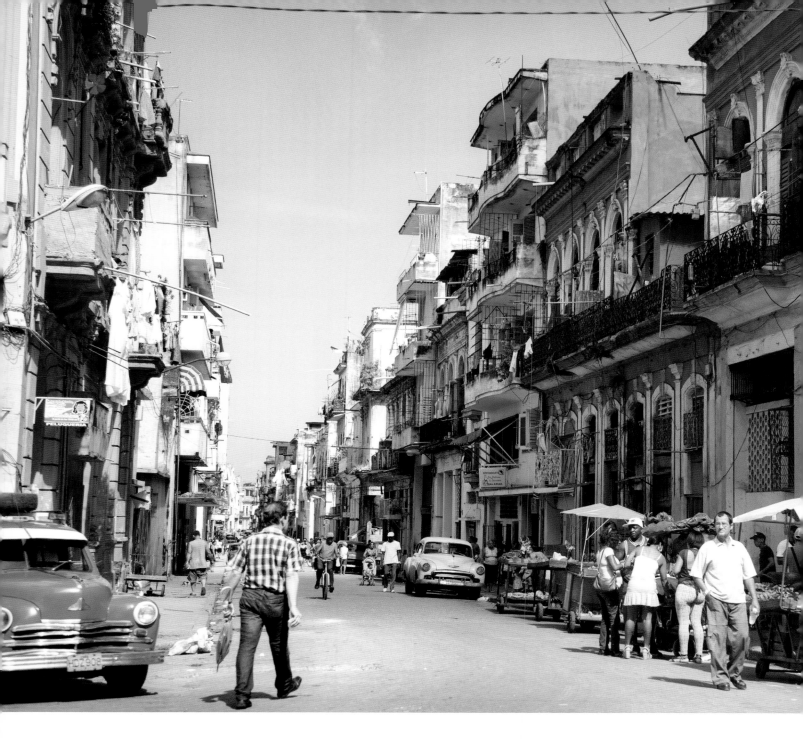

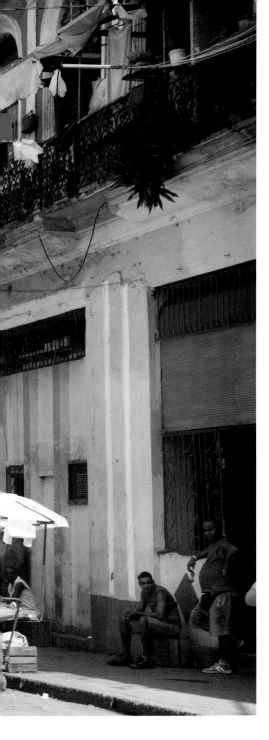

# Centro Habana and Habana Vieja

→ A study in contrasts, these two districts represent all the achievements, challenges and complexities of modern Havana writ large. Habana Vieja, home to the greatest concentration of colonial buildings and landmarks in the hemisphere and a UNESCO World Heritage Site, is Cuba's top tourist destination and example par excellence of how development, restoration, and urban residency can peacefully co-exist. The key is implementing (and maintaining) an economic and social model which remains relevant and mutually beneficial for all involved. Until now, the formula has worked beautifully.

Walk just a few blocks outside of the meticulously restored historic core, however, and you're in the thick of Centro Habana, Cuba's most densely-populated municipality, where a building collapses - partially or entirely - every three days and living conditions can be downright abysmal. Still, folks here know how to make the best of a bad or tenuous situation and the energy in this part of town is as musical and authentic as anywhere else on the island. Perhaps more so: in Centro Habana, personal lives spill into public spaces, urban pluck is elevated to an art, and the daily struggle is on full display, any time of night or day. For those searching for the elusive 'real' Cuba, you need look no further than the loud, gritty streets of Centro Habana.

The street scenes, architecture, and denizens of these two neighborhoods make for superlative photography and people watching; a self-guided walking tour crisscrossing Habana Vieja and Centro Habana will show you more about the Cuban character and daily life than any guide, book or movie. As far as city landscapes go, this pocket of Havana, like other lesser-known neighborhoods including El Cerro, Marianao, and Lawton, is a study in discovery. Indeed, many *capitalinos* from other sections of town would benefit from getting to know these neighborhoods better so as to appreciate the complexities at play.

You just need to look up and behold all the laundry hanging from shallow balconies to know that fashion in these parts is informed by the urban setting: tight and short clothing keep folks cool in the crowded streets, while fluorescent colors and anything with rhinestone detailing satisfies the eye-grabbing style that appeals to many Cubans. Gold chains, diamond studs and other bling like navel piercings – you can get yours done for a buck in Centro Habana, including anesthesia – are ever-popular, as well. Since so much socializing happens on front stoops and in the street, flip-flops (known locally as *chancletas*), easily doffed and donned, and housecoats (*batas de casa*) can be seen everywhere in these neighborhoods.

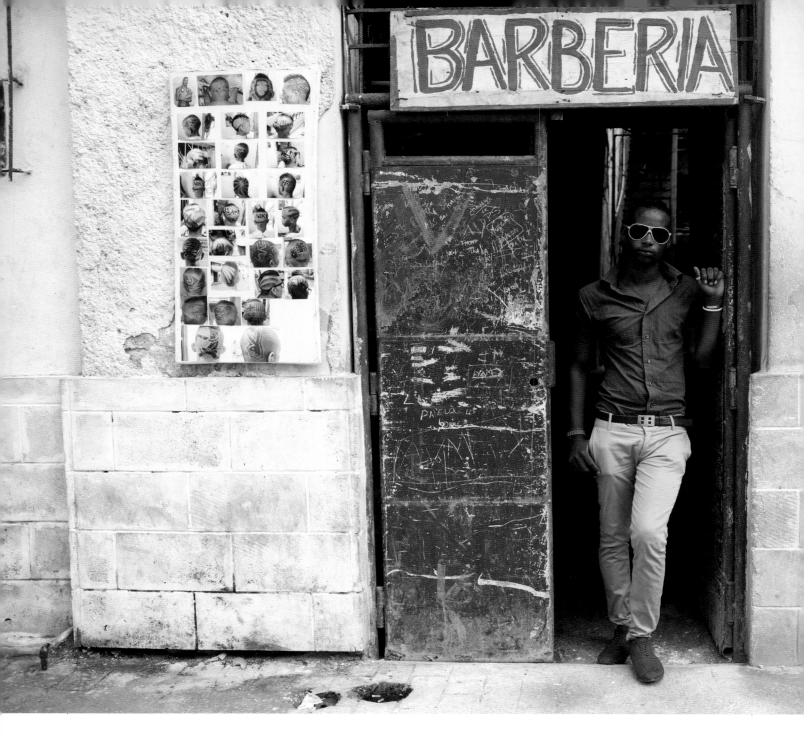

# 'I don't like anything too extreme, I prefer the natural and casual look.'

— CARLOS

Carlos (20)
Gastronomy student

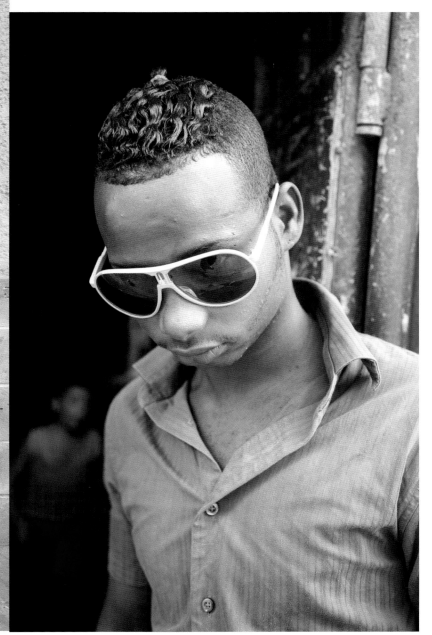

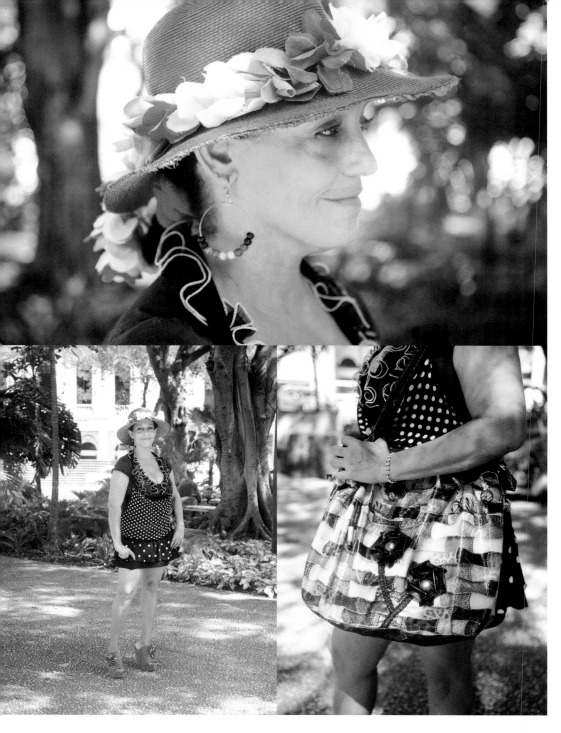

### Rosa Maria (44)
Florist

### Yoissel (28) →
Professional Cook

**How would you describe your style?**

I like to mix light and dark colors, but with a style that is my own, to find a different take on what is currently in fashion, small details that mark a difference. My younger brother and I wear similar clothes because we have the same clothes, the same shoes and now we're looking for a pair of stylish leather shoes at a hotel boutique.

**Do you think fashion is more important now that it was ten years ago in Cuba?**

It's more important now because I have grown up. Maybe I didn't notice before because I was young but now I see it's more important than in the past. Fashion is always going to be important. Our parents were young and had other fashions. Today we wear fashions that are echoing a time before us, but with modern twists.

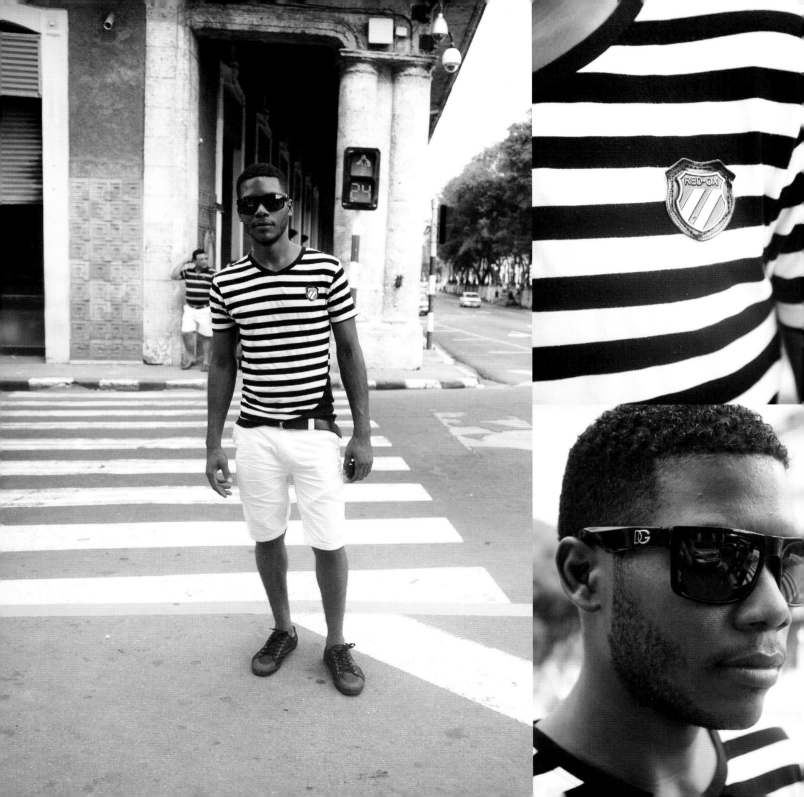

'Sometimes I look at people in the street, their styles, how they dress, and from there I get my own ideas.' – ALIOSHA

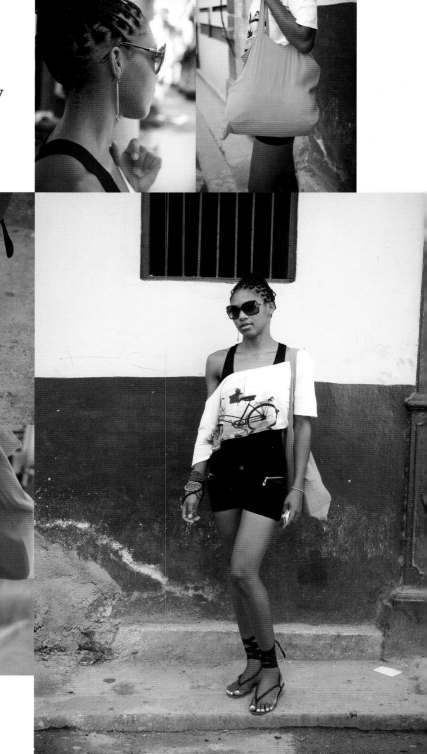

**Aliosha (28)**
Professional Model

**Pablo (29) →**
Professional Cook

**Describe your fashion.**
Well, fashion is fabulous. I always want to be ahead with the topic of fashion. If it's tight, then tight, the belt, pants, I like to be "in the fashion", this is fantastic for me.

**How important to you are brands?**
It's not easy, the economic situation can change here so some people have opportunities and others don't depending on the economy. I was lucky to study in one of the most prestigious cooking schools of the city and more or less I am keeping up, but it's not easy in reality.

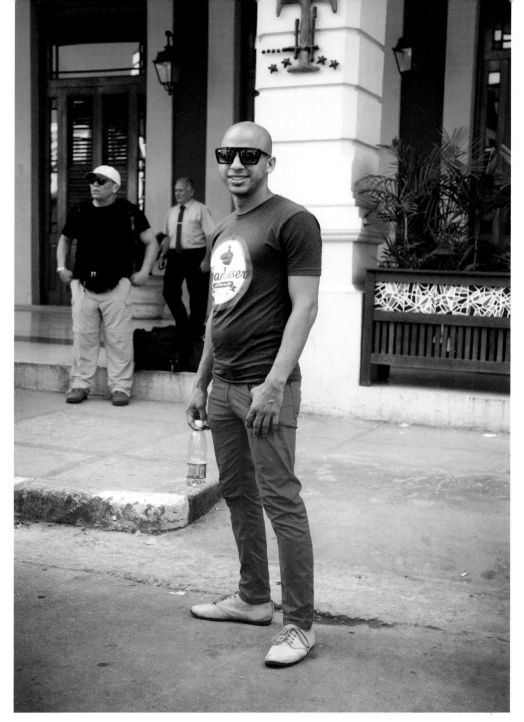

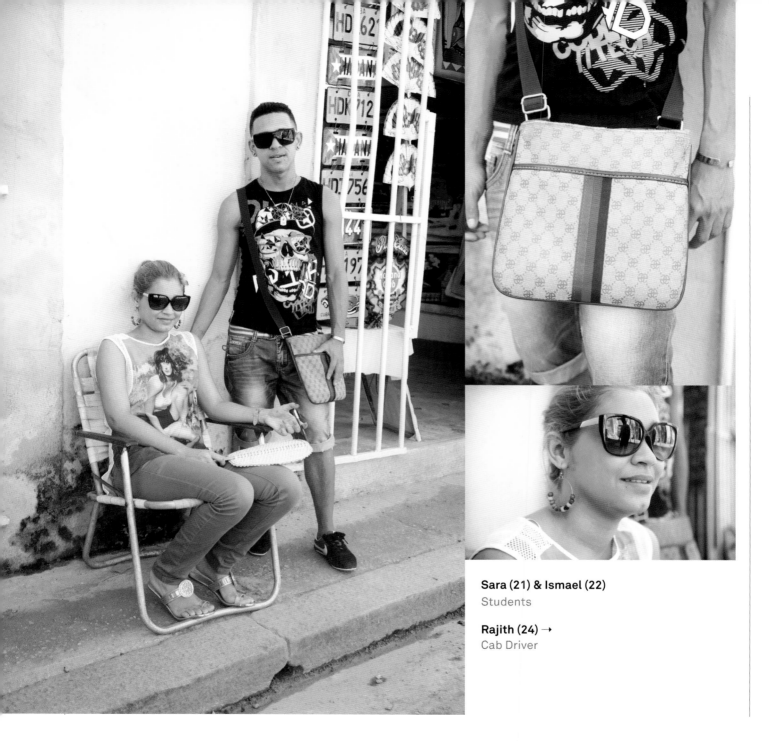

**Sara (21) & Ismael (22)**
Students

**Rajith (24) →**
Cab Driver

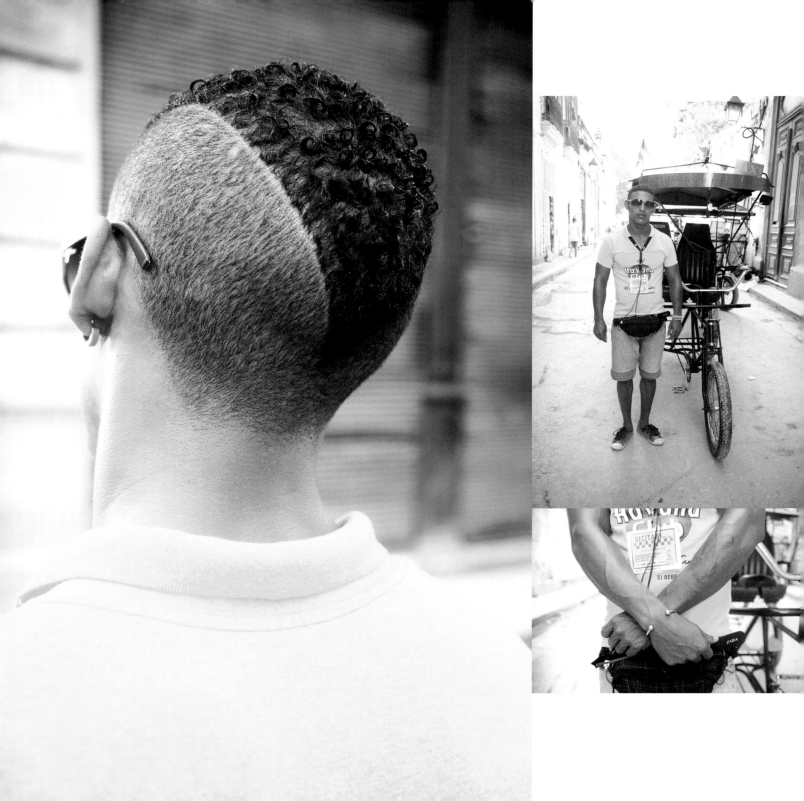

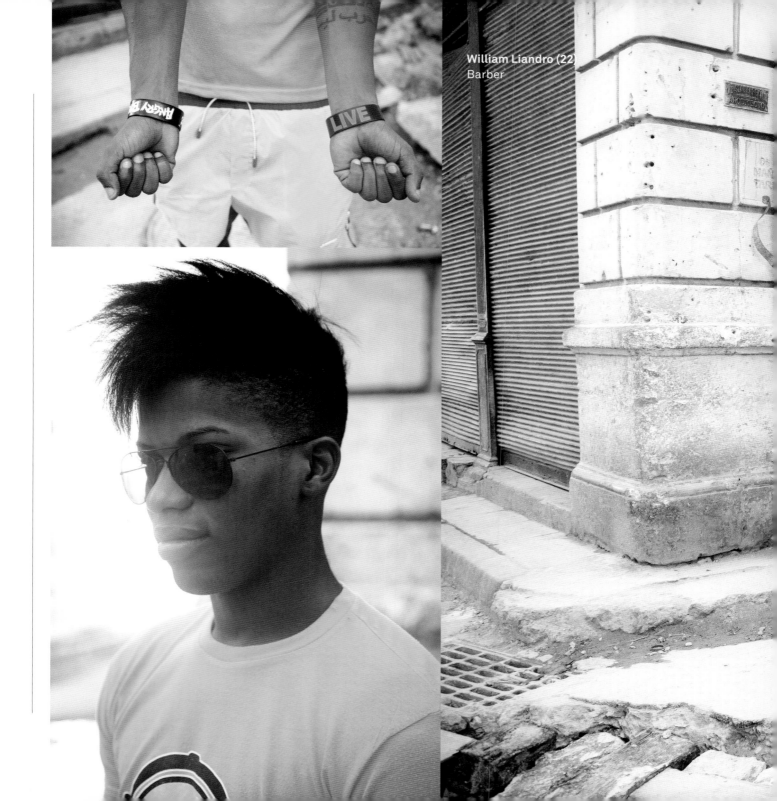

William Liandro (22)
Barber

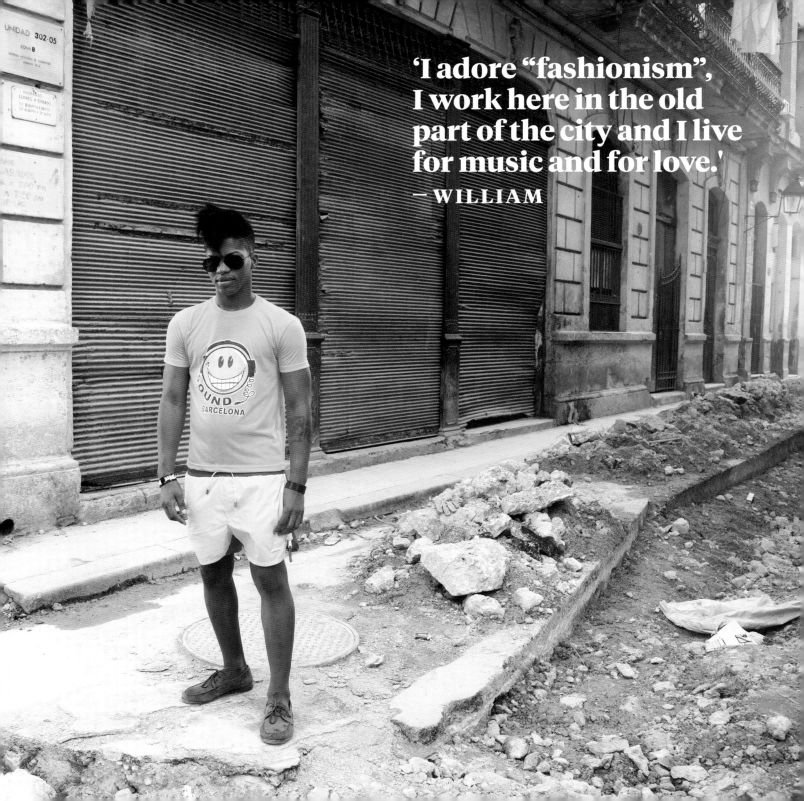

'I adore "fashionism",
I work here in the old
part of the city and I live
for music and for love.'
— WILLIAM

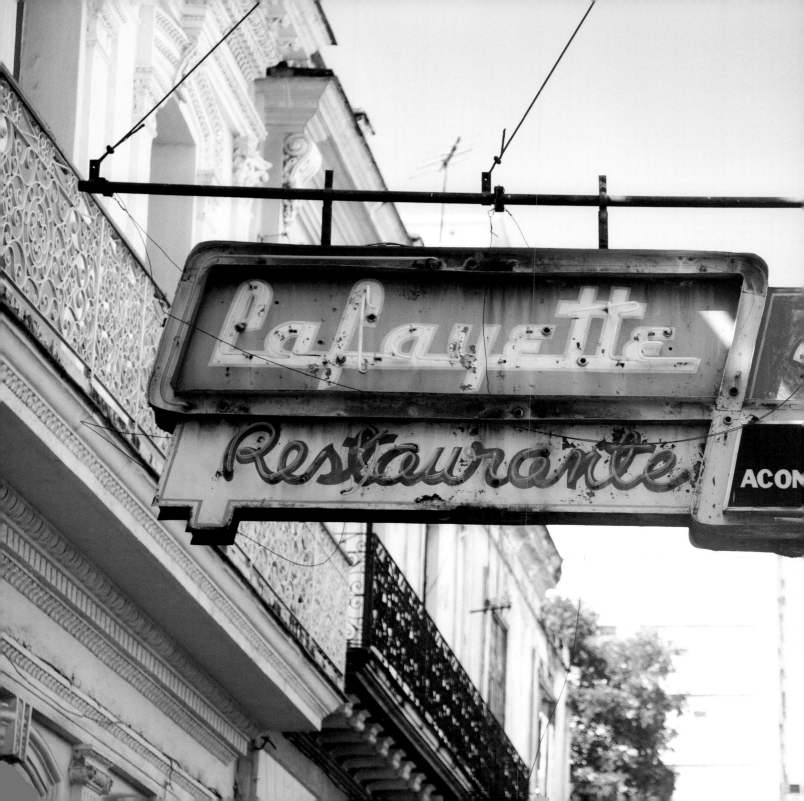

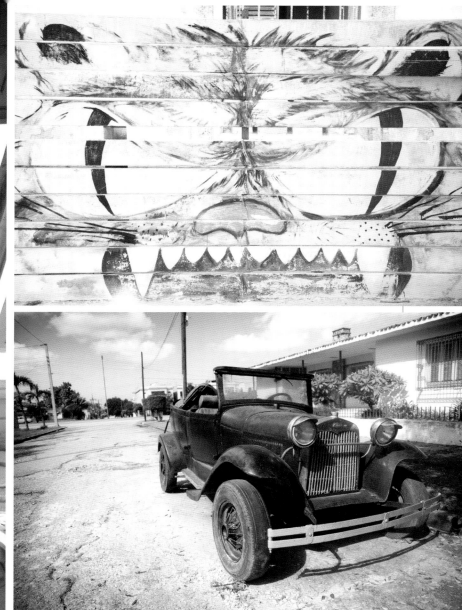

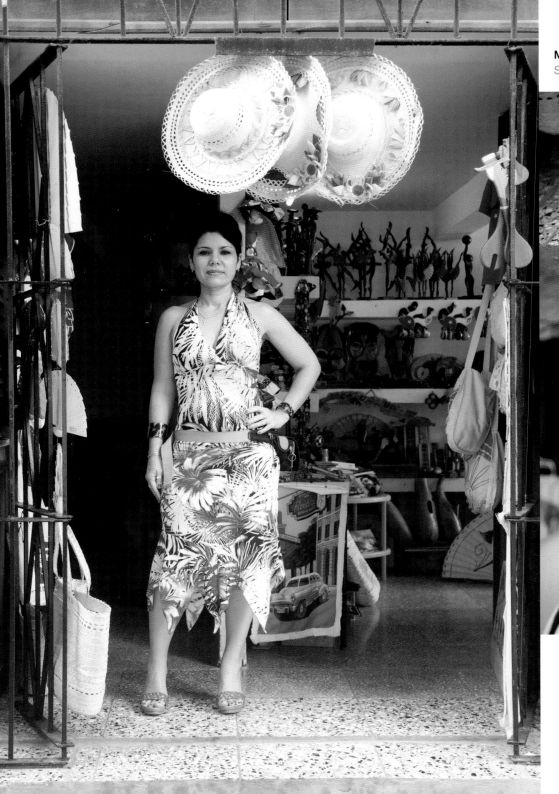

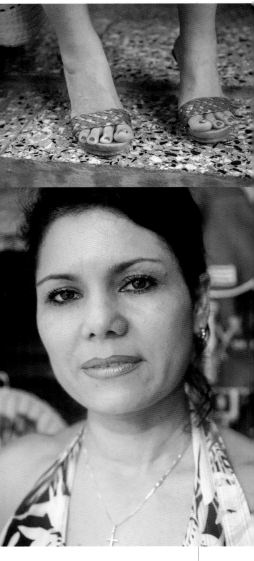

**Mayori (36)**
Storekeeper

'I always like to wear high
heels so I look elegant.' – MAYORI

**Wilder (22)**
Student

**How do you describe your style?**
Well, my personal style is a bit crazy, to go against the rules of whatever is the norm of the community, in general it is to break with the current canons of the Cuban society.

**Do you have a fashion icon?**
Well, yes, mostly European fashions, startinging with Melendi, who is one of my idols, and the rest are small things one takes from this country or that artist. I like to mix it up.

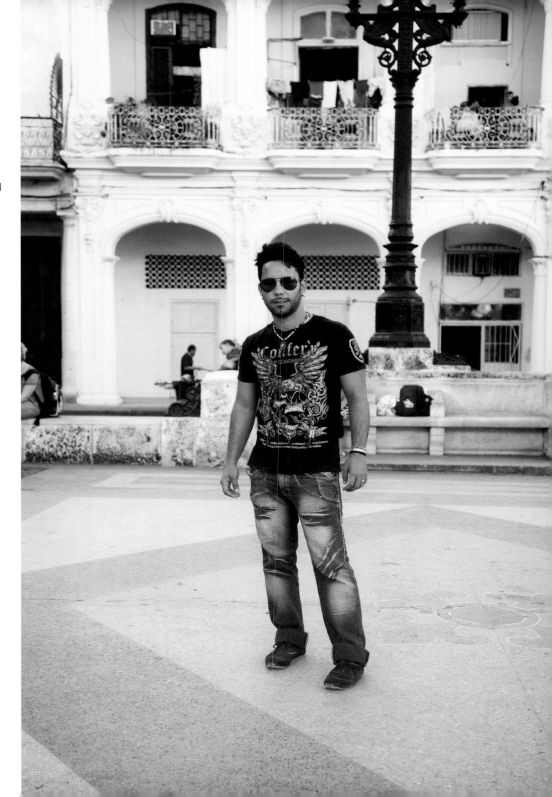

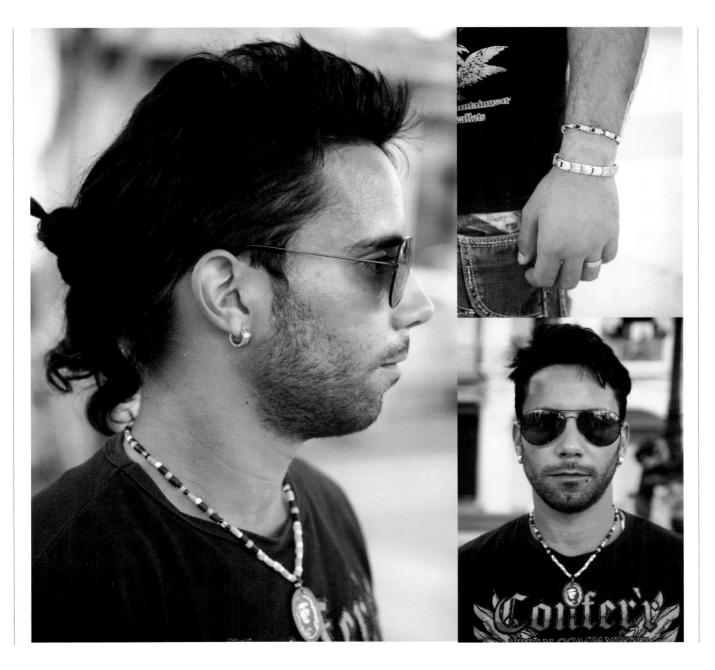

**Orlando (42)**
Self employed

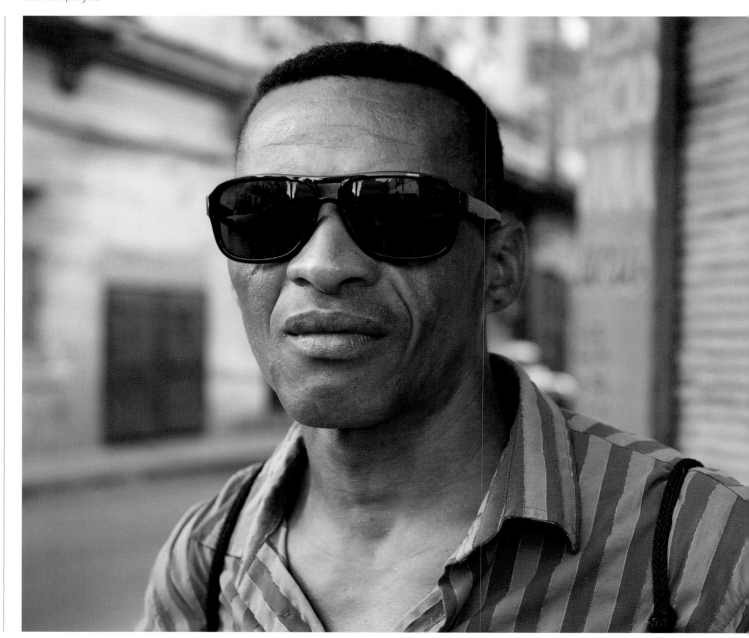

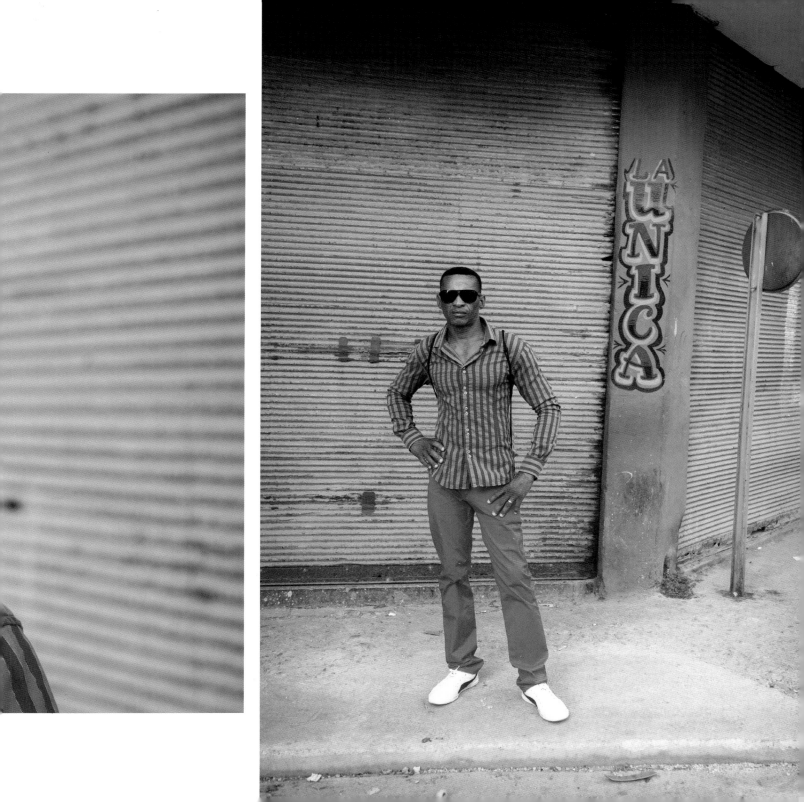

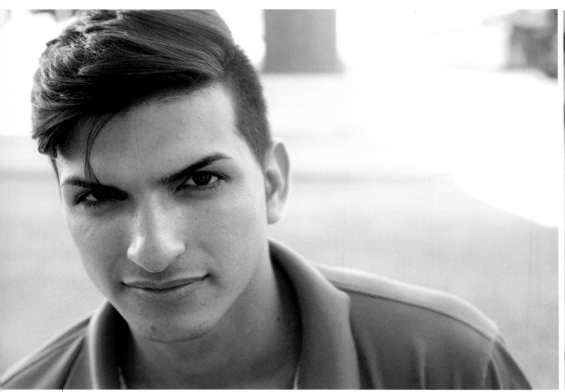
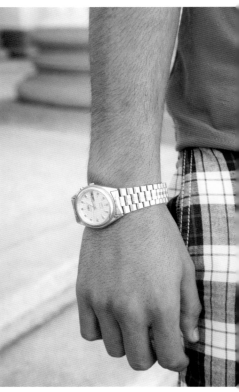

**Luis Enrique (21)**
Sociology student

**Claudia (21)** →
Sociology student

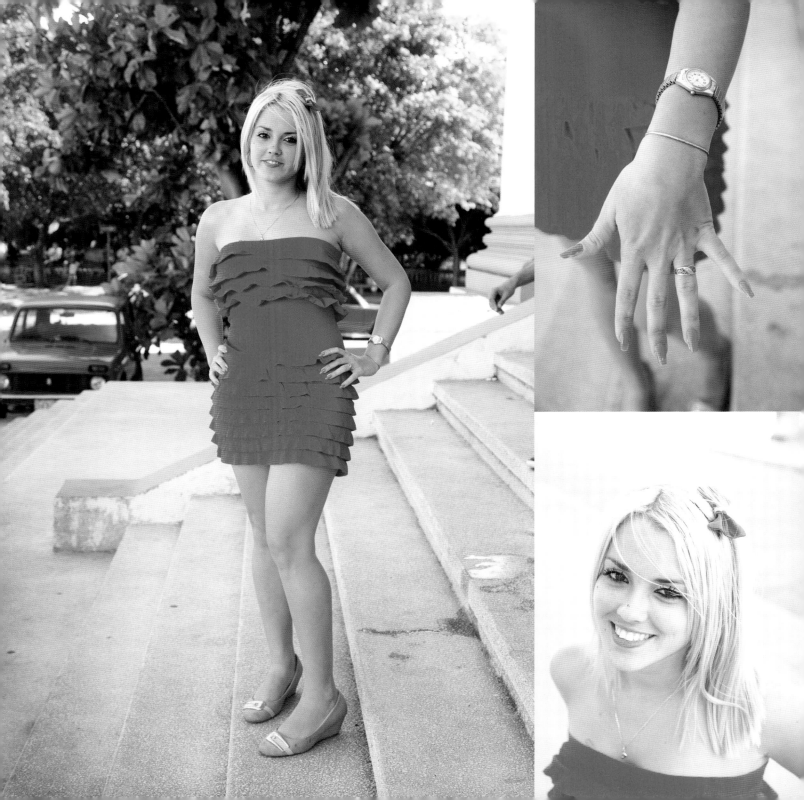

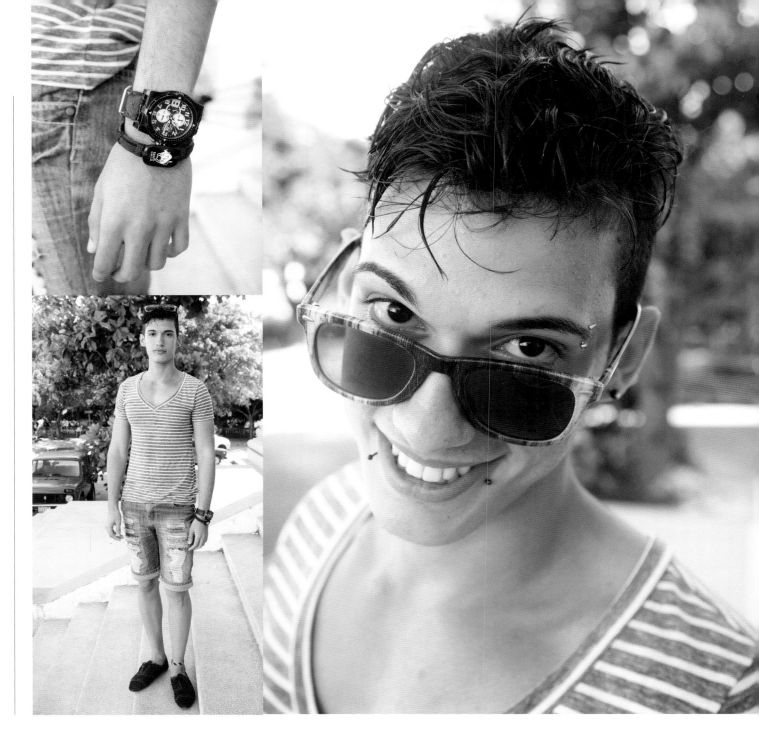

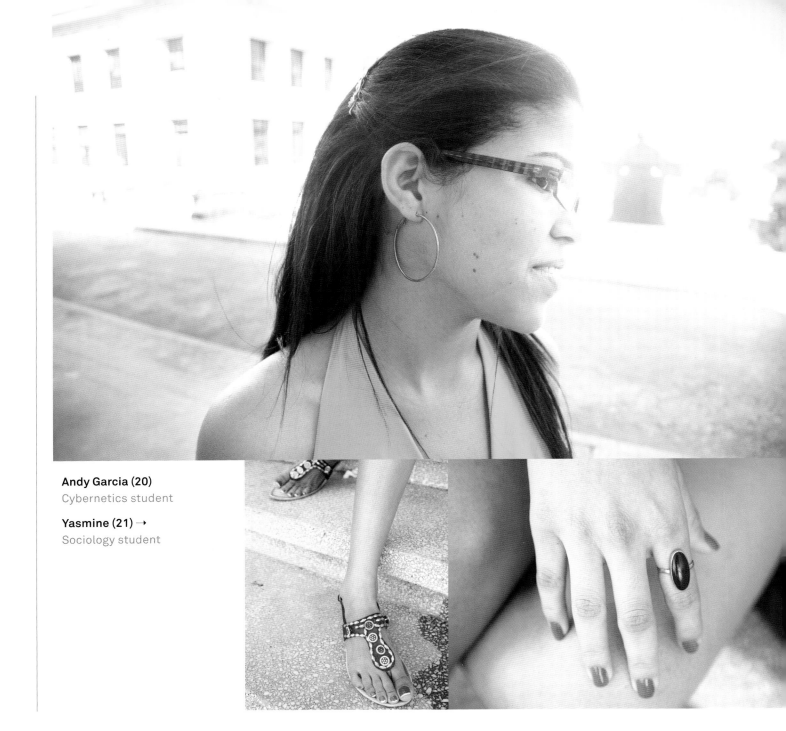

**Andy Garcia (20)**
Cybernetics student

**Yasmine (21)** →
Sociology student

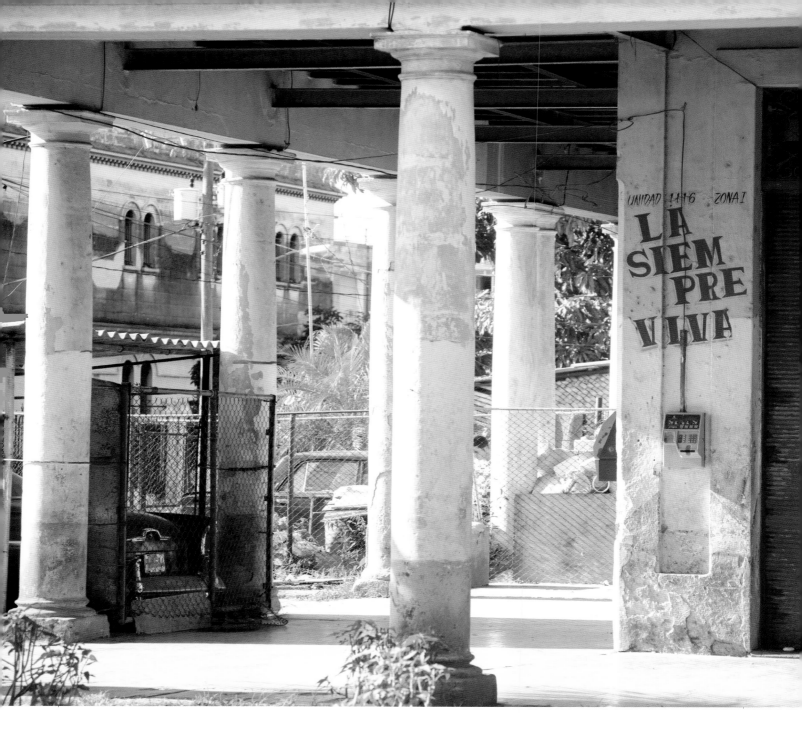

# Vedado and La Rampa

→ Hot, hip, and verdant, Vedado is at the heart of Havana's emerging gestalt. Indeed, there is perhaps no better setting in the city for getting an intimate look at Cuba's ongoing economic reforms than amongst the shady boulevards and porticoed mansions which are the hallmark of this preferred residential and happening nightlife district. Here, private business is booming, homes are being restored to pre-revolutionary splendor, and outdoor music festivals - once as rare as a steak or Internet connection - are now regular occurrences. In short, Vedado is fast becoming younger and more fabulous as the new moneyed class moves in and older, less affluent folks move out.

Vedado's electric energy is palpable and harkens back to the days when wise guy Meyer Lansky held court in his opulent Hotel Riviera and Ava Gardner received suitors on the terrace of the Hotel Nacional - both of these historic properties are neighborhood landmarks and recommended for lingering over a mojito or three. The jazz clubs in this district are legendary, as are the cabarets, rivaled only by the world-famous Tropicana, a short taxi ride away. Whether it's to dine or dance, step out any night in Vedado and you'll appreciate the care Cubans take with their grooming and dress: on the whole they are renowned for looking and smelling good at all times, for all occasions and nowhere is this more evident than on a weekend night in swinging Vedado.

Crossing from scrappy Centro Habana into Vedado is the quintessential tale of two cities - one is an overcrowded, tree-less concrete jungle, the other a veritable oasis of wide streets and luxury high-rises with sweeping views of the Malecón and the sparkling sea beyond. Laid out on a grid, Vedado stretches from the Malecón and 23rd Street (known as La Rampa), to the Puente Almendares and inland to the Plaza de la Revolución. The entire district is peppered with lovely pocket parks - like the quirky John Lennon park with its lifelike statue of the beloved Beatle perched on a bench - and an astounding collection of eclectic architecture from Art Deco (e.g. the Casa de las Ámericas on Calle G) to modernist (the can't-miss Focsa building, looming over Calles 17 and M, is the most obvious example).

One aspect of Vedado which stands out in terms of street style is the heavy presence of 'repas' – slang for suburbanites or what New Yorkers call 'the bridge and tunnel crowd.' These are folks who don't actually live in the city, but come into town to flirt, party and show off their favorite outfits. Generally these get-ups feature recognizable brands including D & G, Gucci, or Ed Hardy (knock offs, likely) and trends which went out (or were never in) several years ago like distressed jeans, knee-high sneakers, and v-neck t-shirts, worn tight and low to show off the boys' shaved chests. Another peculiarity to Vedado is Parque G, running along Calle G from Calle 23 to Línea. Here, all sorts of fashion renegades congregate on weekend nights, when you can find hundreds of emos, rockers, goths and other non-conforming types, known here as friquis, playing music, drinking, gossiping and comparing their tattoos and piercings.

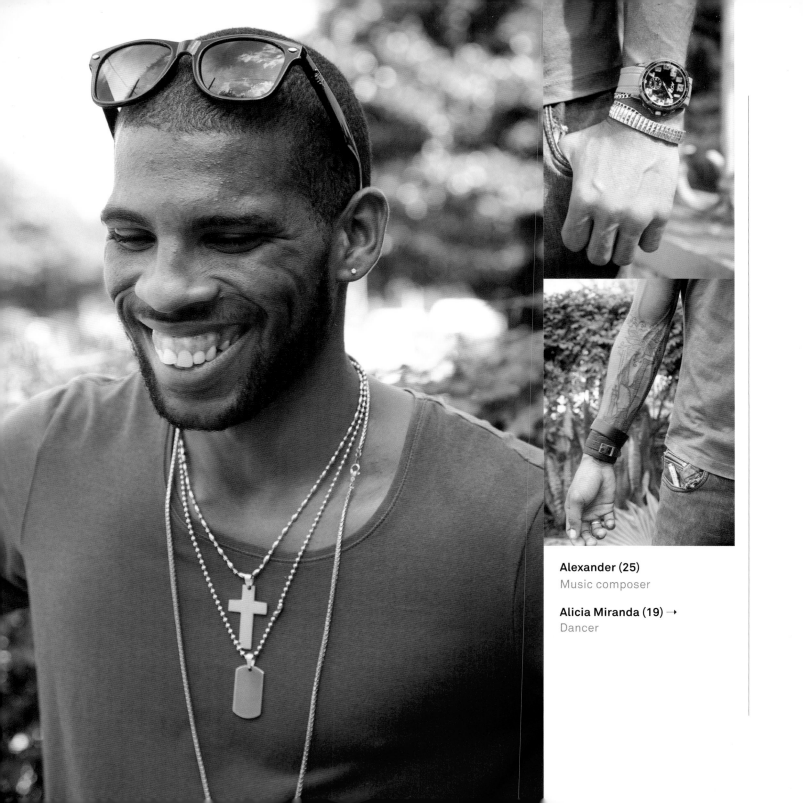

**Alexander (25)**
Music composer

**Alicia Miranda (19)** →
Dancer

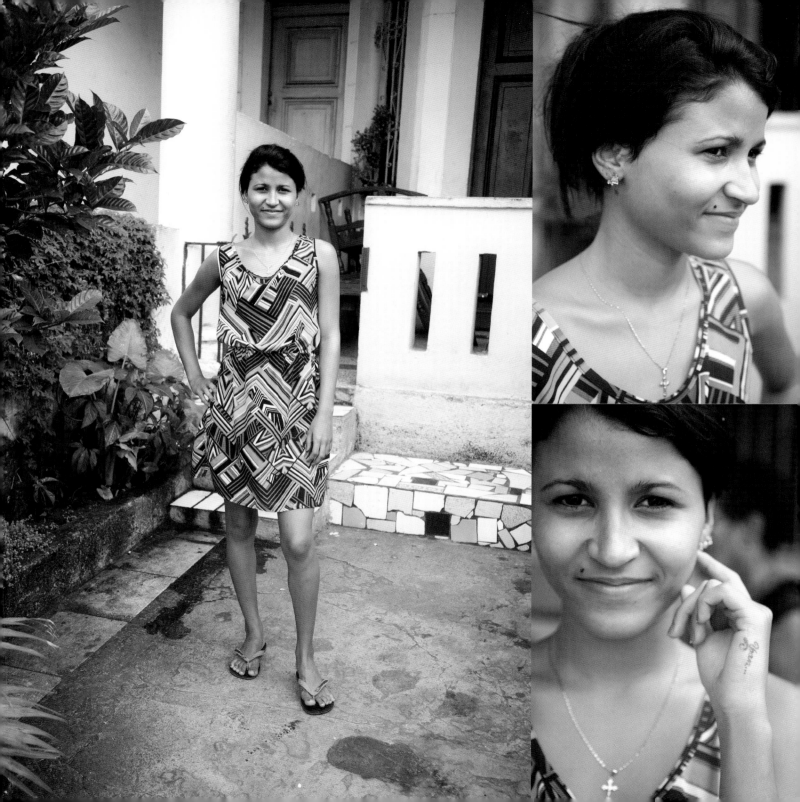

**Jeison (21)**
Physics student

**Yauisleidys (19)**
Food science student

**How do you describe your style?**
I'm really inspired by Cameron Diaz
but I think I have my own style. I like
to wear loose shirts, tight pants, high
heels, mixing bold colours with subtle
but elegant jewellery.

**Where do you buy your clothes?**
Mostly in the private shops or the
street markets and occasionally in the
hotels and boutiques.

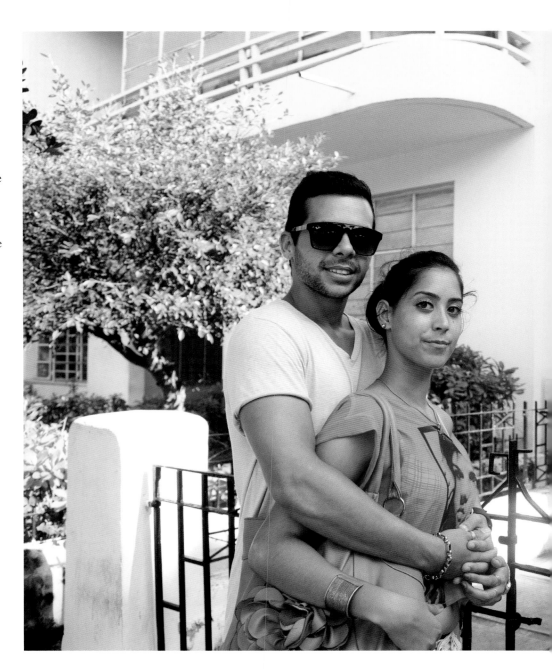

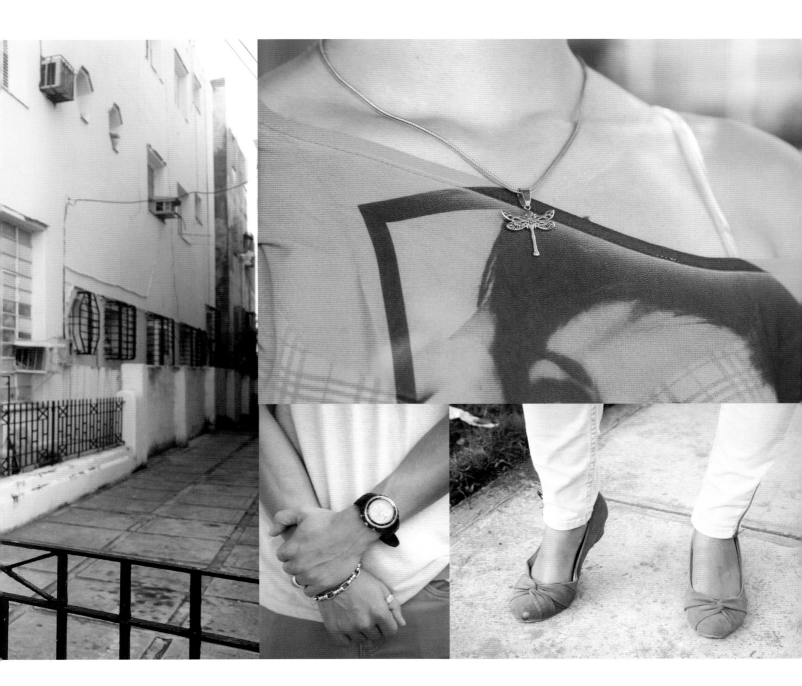

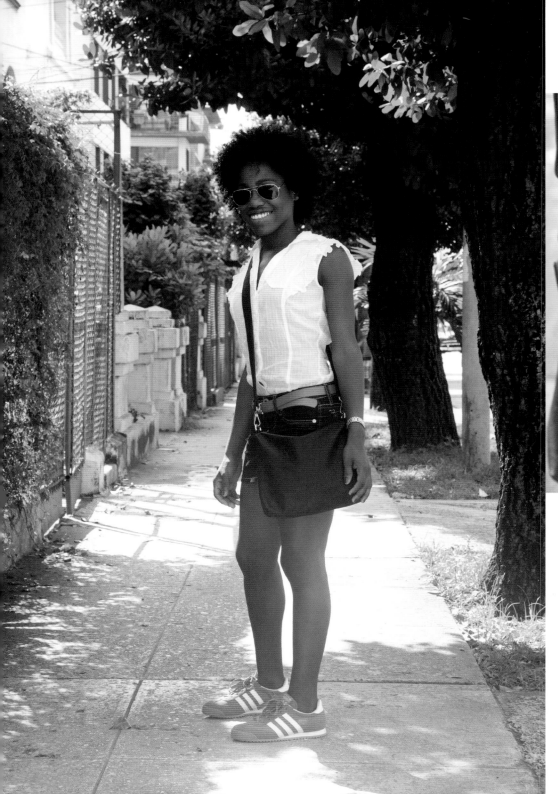

'I like how
Chris Brown
dresses -
casual but
colourful.'

— MILAILA

**Yadira (25)**
Dancer

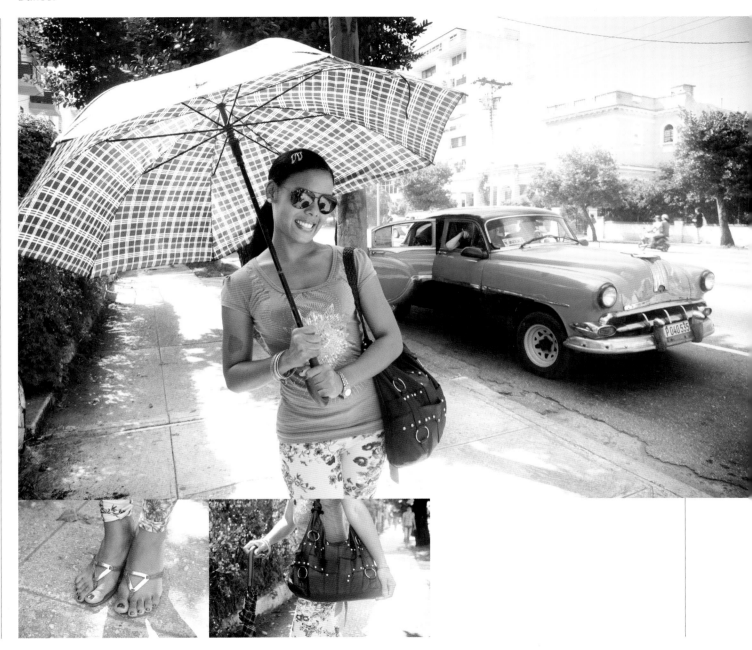

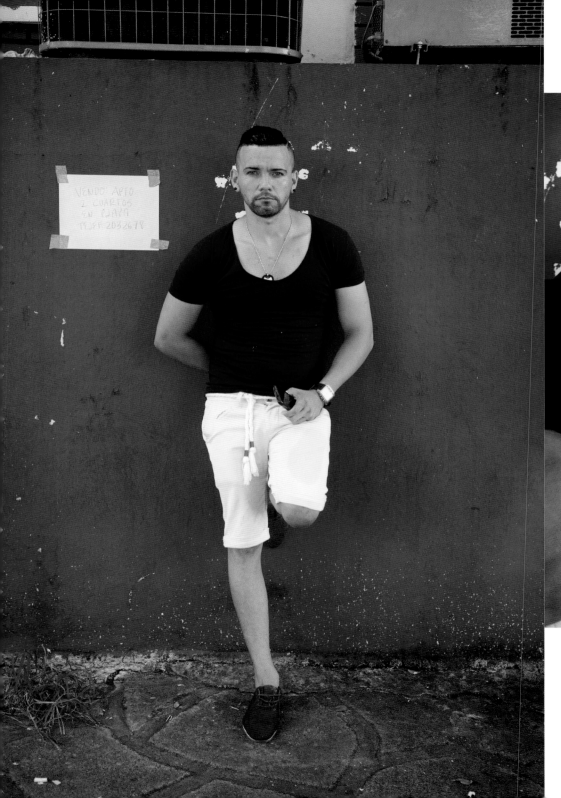

**Eduardo (23)**
Accounting student

**Mónika (24)** →
Musician

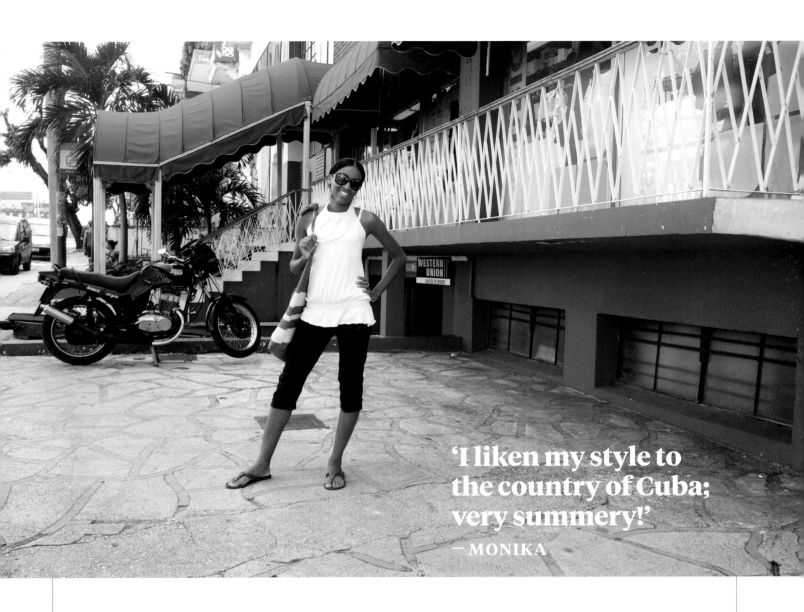

'I liken my style to
the country of Cuba;
very summery!'
— MONIKA

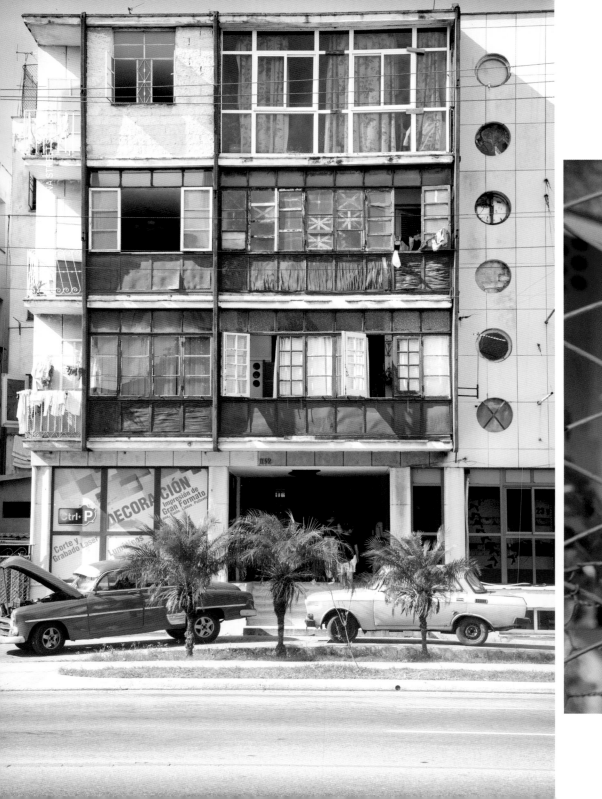

**Thais (24)**
Dancer

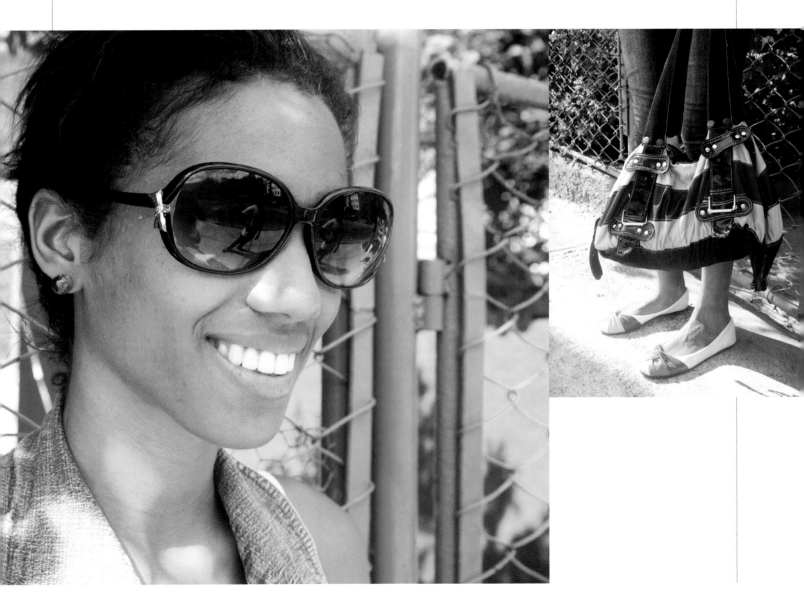

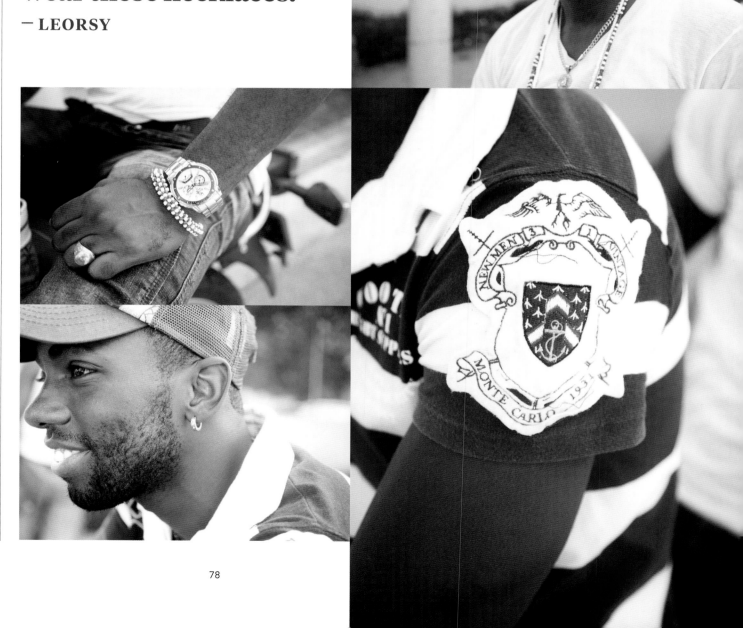

'I am a religious
person that's why I
wear these necklaces.'

— LEORSY

**David (27)**
Mechanic

**Leorsy (40)**
Professional chef

Good friends David and Leorsy both
describe their style as 'retro' preferring
a comfortable and simple combination
of t-shirts, hats, sunglasses and sports
shoes that suit the Cuban climate.
David wears a read and white necklace
often associated with the syncretic
religion of Santería, which combines
the Yoruban religion of the African
slaves with Catholicism and some
Native American strands.

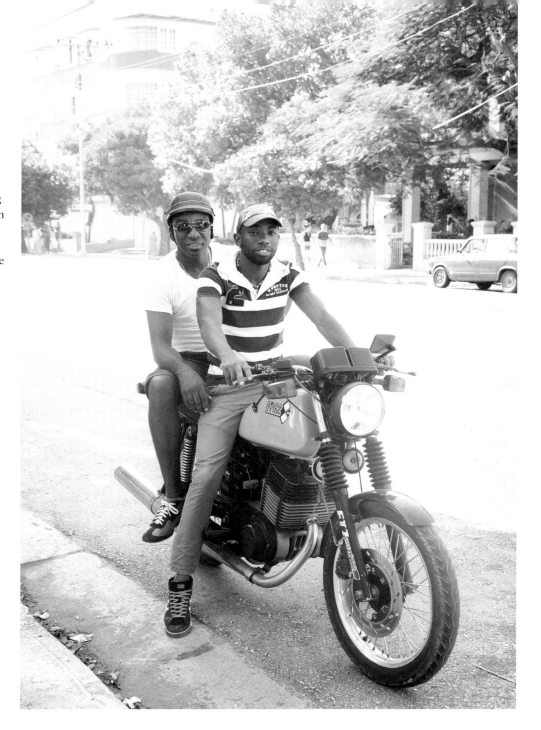

**Dayana (19)**
English student

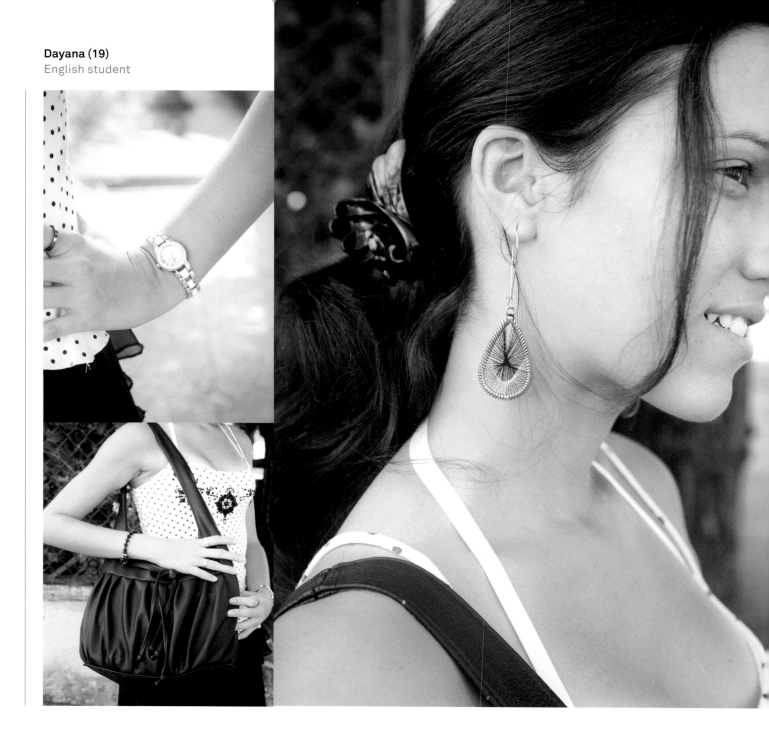

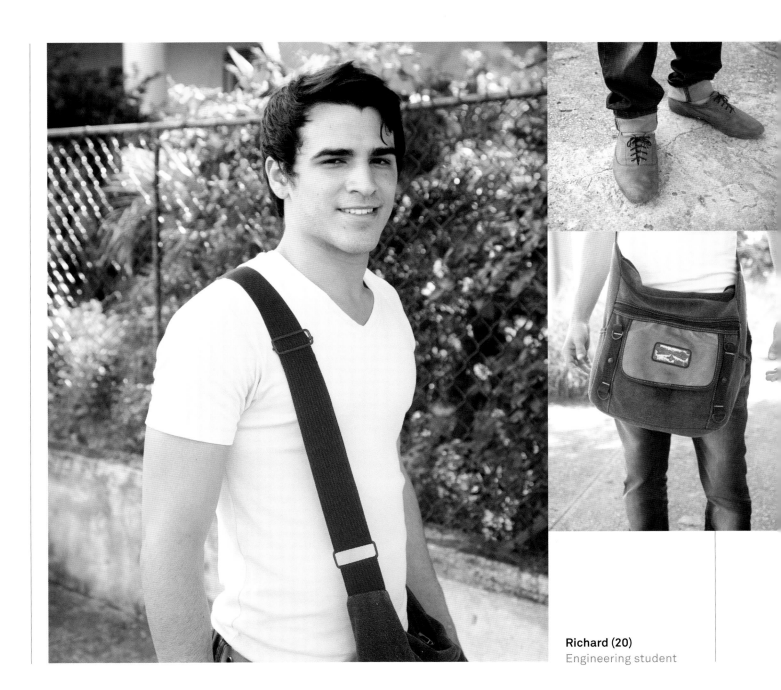

**Richard (20)**
Engineering student

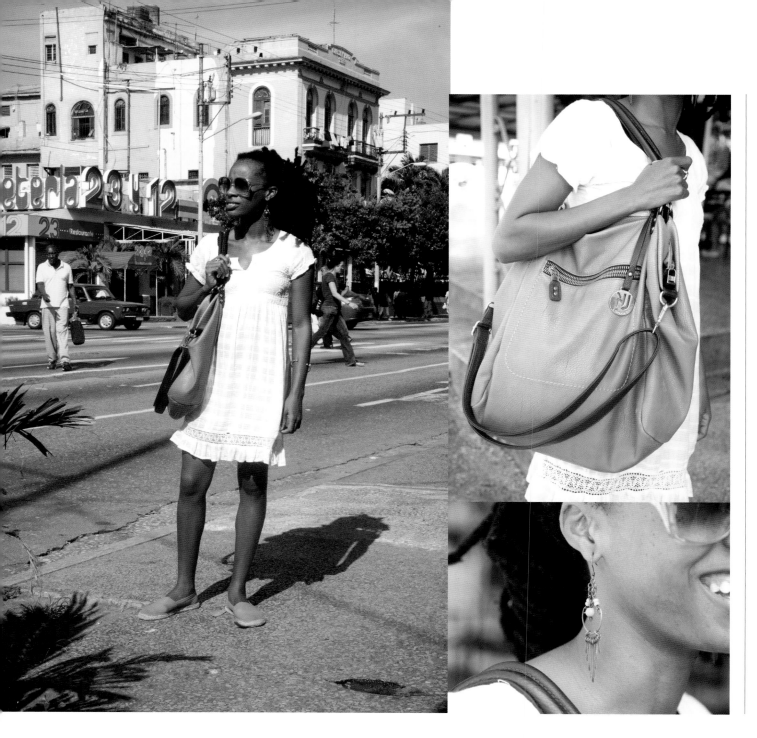

**Afibola (25)**
Religious Sciences student

### How would you describe your fashion, your style?

Well, that's difficult. Let's see. I dress in an extravagant way because I like the extravagant style and I like that people notice that I am passing by, so I dress in a way that calls people's attention and I try to follow fashion patterns, but not in a rigorous way. But if I feel that among the things that are in fashion there's something that has something to do with me, I wear it, and if not, I don't. And if there's something that has to do with me, but is not in fashion, I may wear it too.

### Where do you buy your clothes?

Well, I *steal* from my friends, but in the last few years since my sister moved to Italy, I get lots of clothes that she sends me, but most of my clothes I get second hand, "recycled clothes". Many people do it but they feel ashamed.

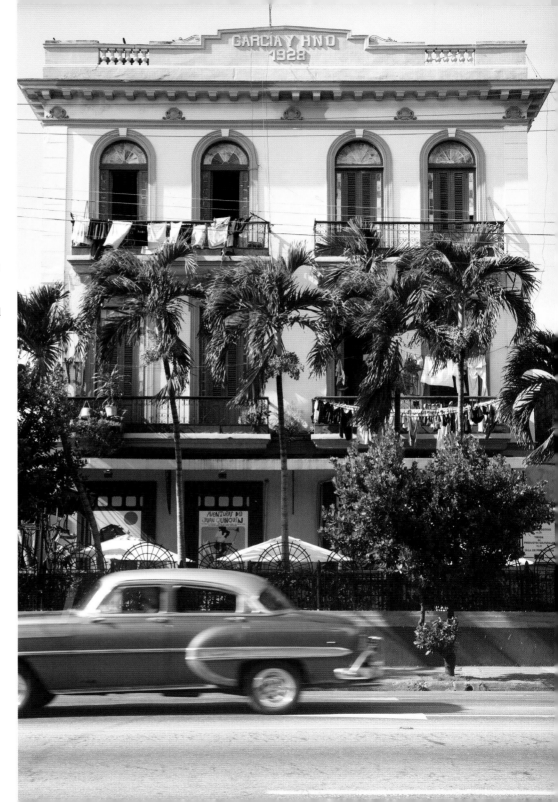

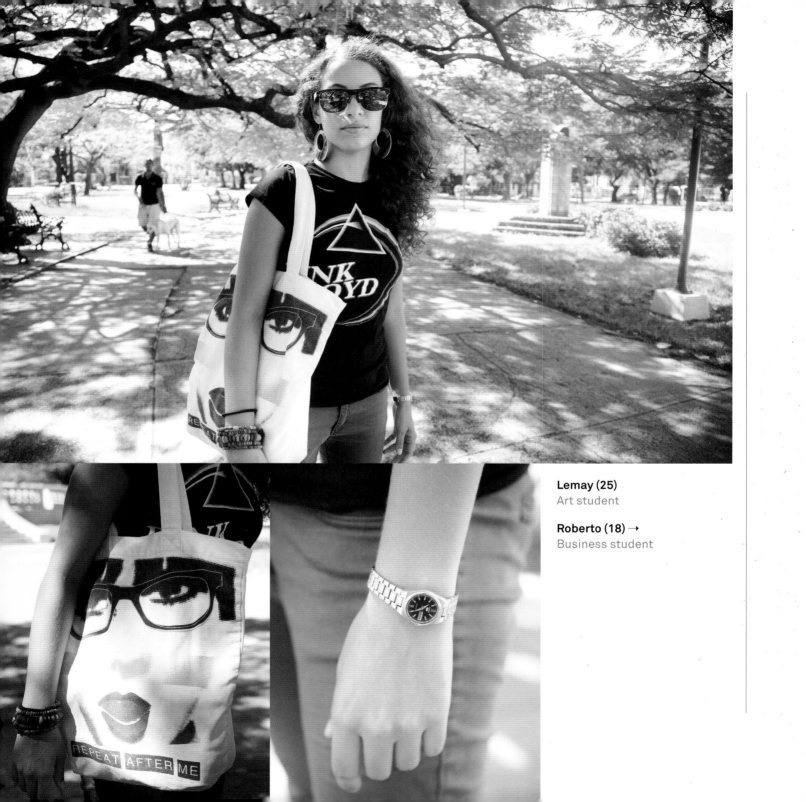

**Lemay (25)**
Art student

**Roberto (18) →**
Business student

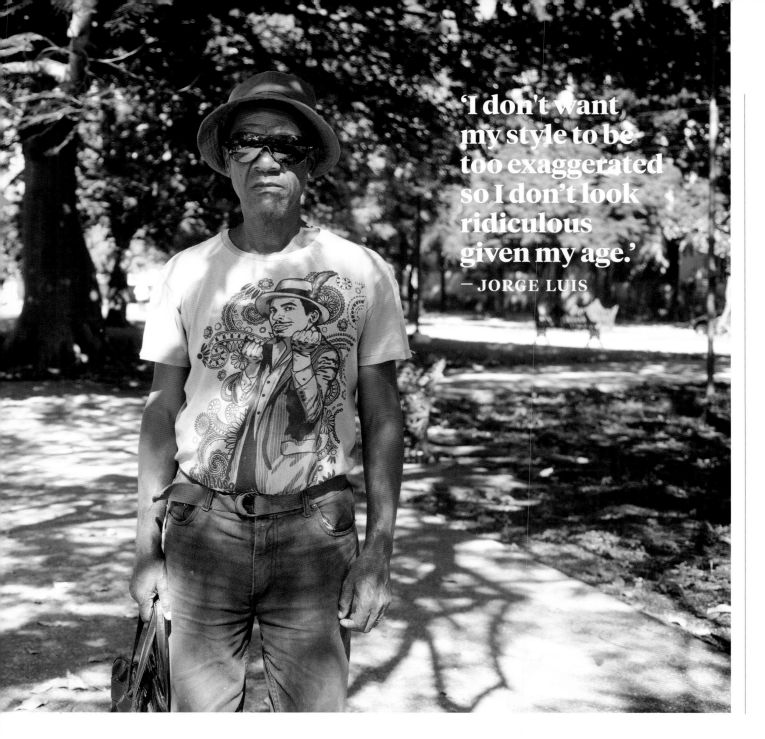

'I don't want
my style to be
too exaggerated
so I don't look
ridiculous
given my age.'
— JORGE LUIS

86

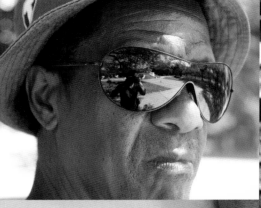

**Jorge Luis (60)**
Car mechanic

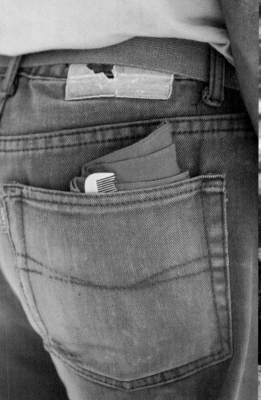

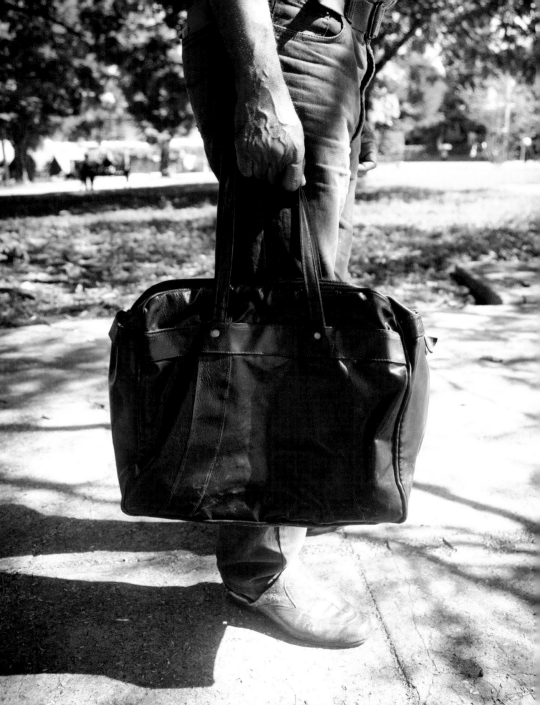

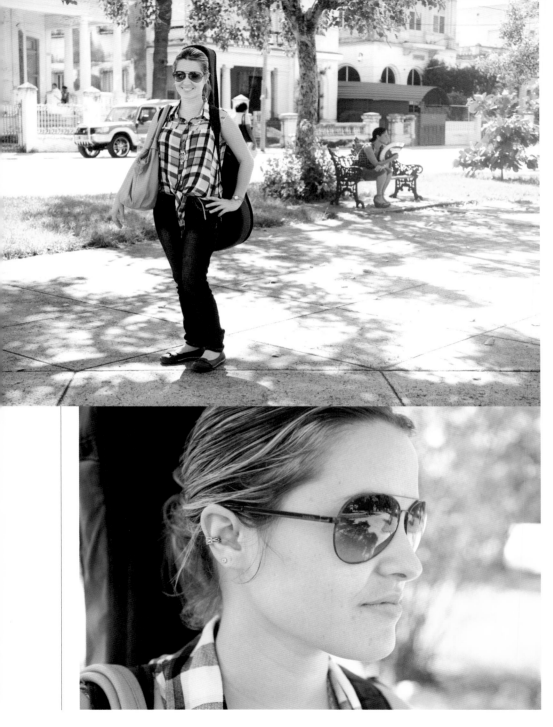

### Helen (23)
Musician

### Lemain Martinez (32) →
Musician

**How would you describe your fashion, your style?**
I think that fashion is good, that it always keeps changing, because I think the way we dress should always change, and that everybody should wear whatever they like and whatever suits them.

**And how do you like to dress?**
Well, I sometimes mix, sometimes I dress in white... Sometimes I tie my hair, I wear braids..., I like to dress according to fashion, but also depending on my financial situation because fashion is expensive, and I think one should adapt to that and dress according to what you can get and what suits you. I always try to dress well and elegant and if I don't have to buy whatever is in fashion, at least to be clean and presentable.

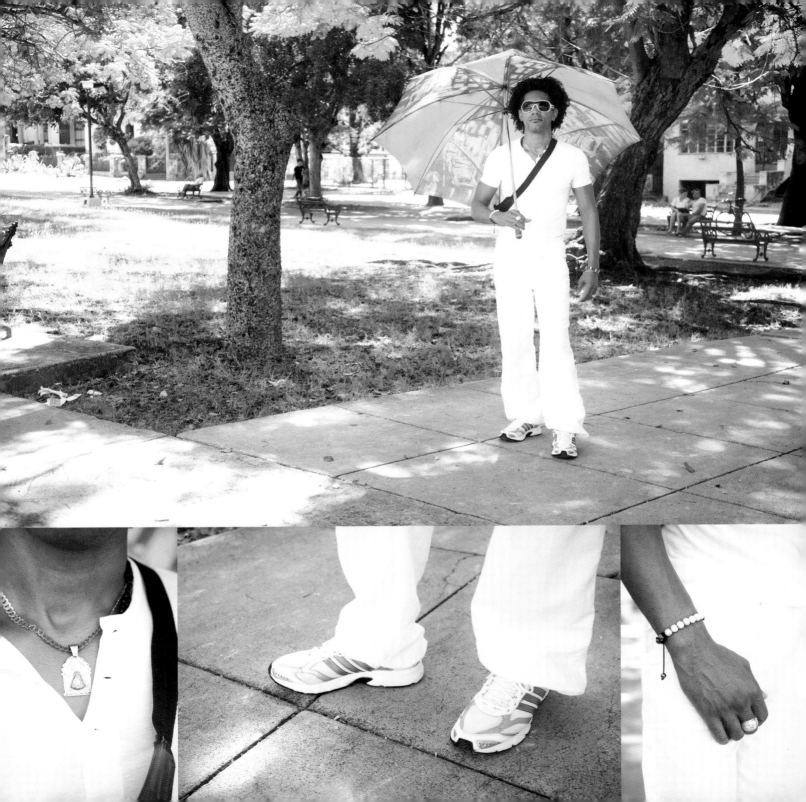

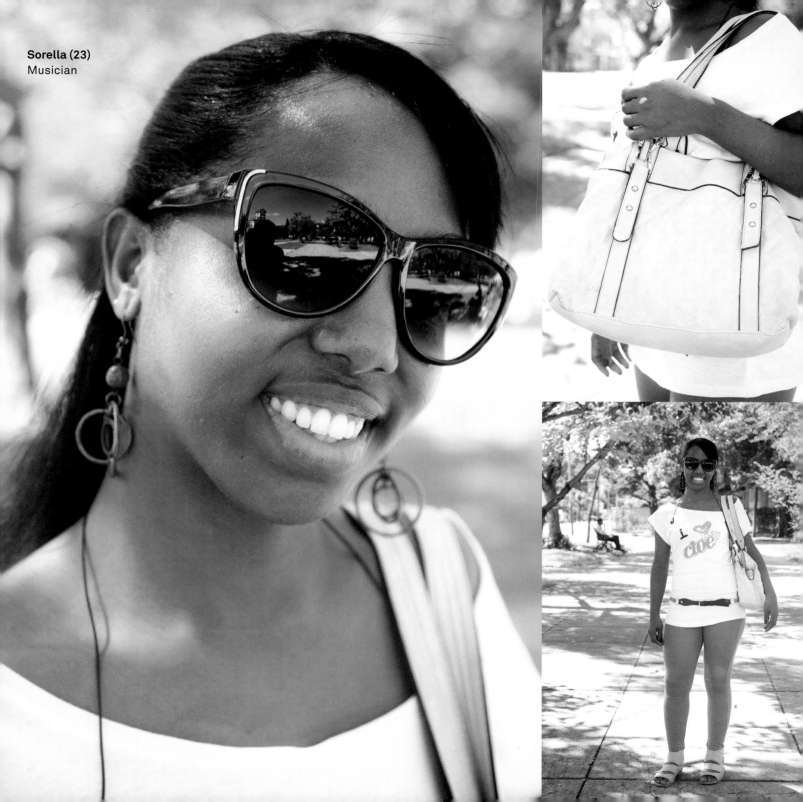

**Sorella (23)**
Musician

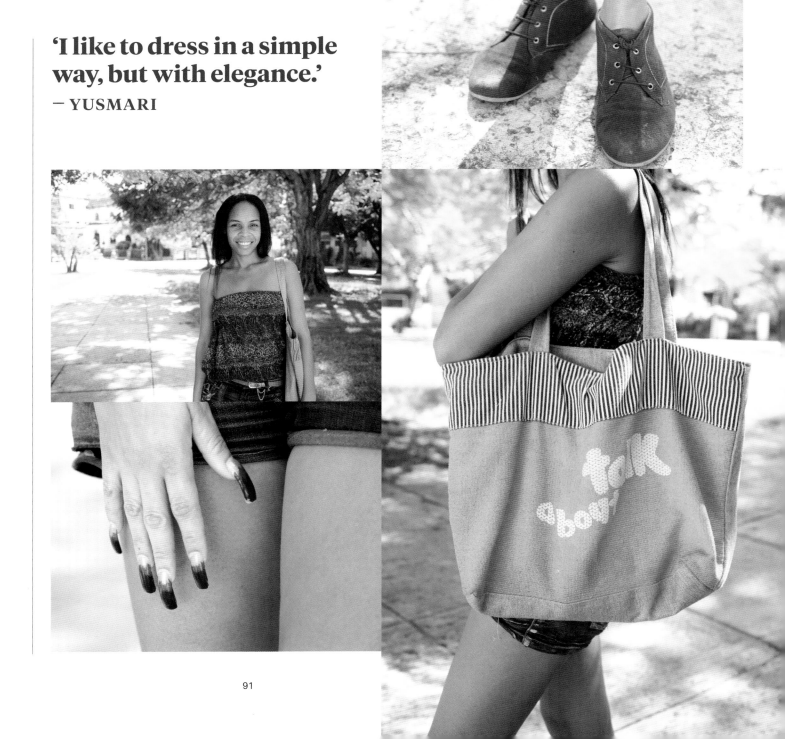

'I like to dress in a simple way, but with elegance.'
— YUSMARI

91

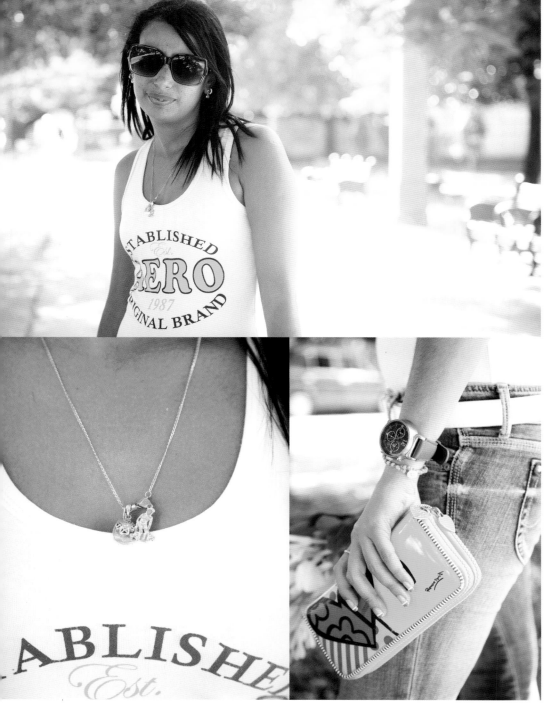

**Alejandro (43)** →
Painter

**Sorella (23)**
Teacher

**How do you describe your style?**
I like to dress in a freewheeling style, not formal, with this heat that we have in Cuba you need a fresh and colorful style - usually with sandals that are comfortable to wear and walk in.

**Do you have any fashion icon?**
For me, one of my idols in fashion is Alicia Keys, I love her and regarding brands, I love Lacoste.

**Where do you buy your clothes?**
I buy lot of my clothes in private stores, not in the government ones. But generally friends and relatives abroad send me things. It's more difficult to find clothes that suit me here, but oh well...

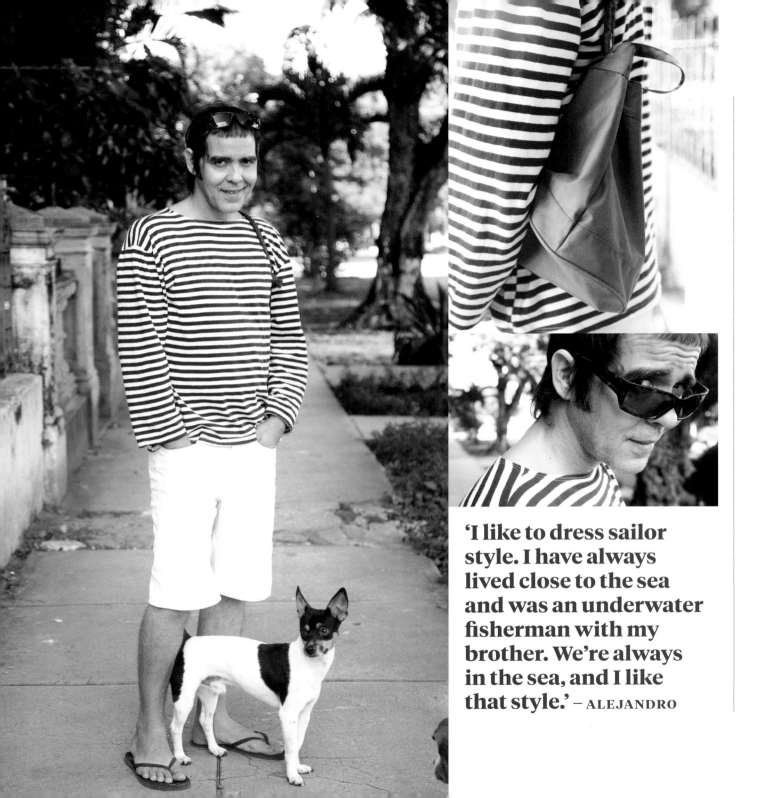

'I like to dress sailor style. I have always lived close to the sea and was an underwater fisherman with my brother. We're always in the sea, and I like that style.' – ALEJANDRO

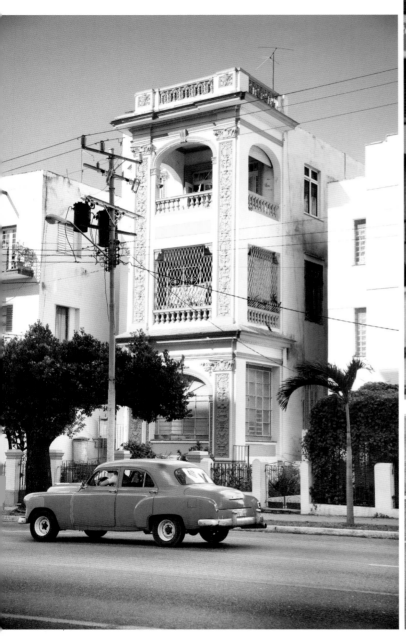

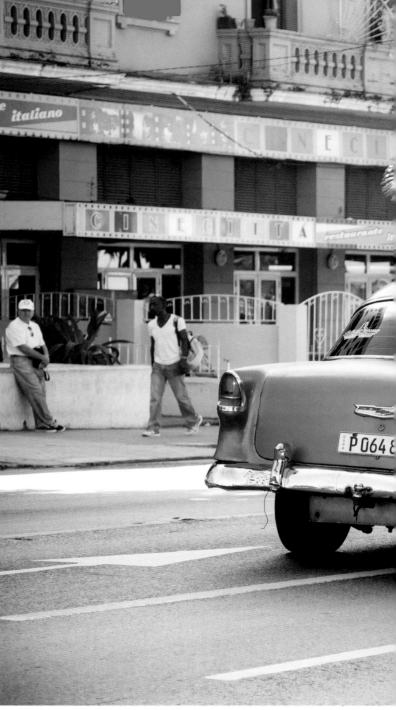

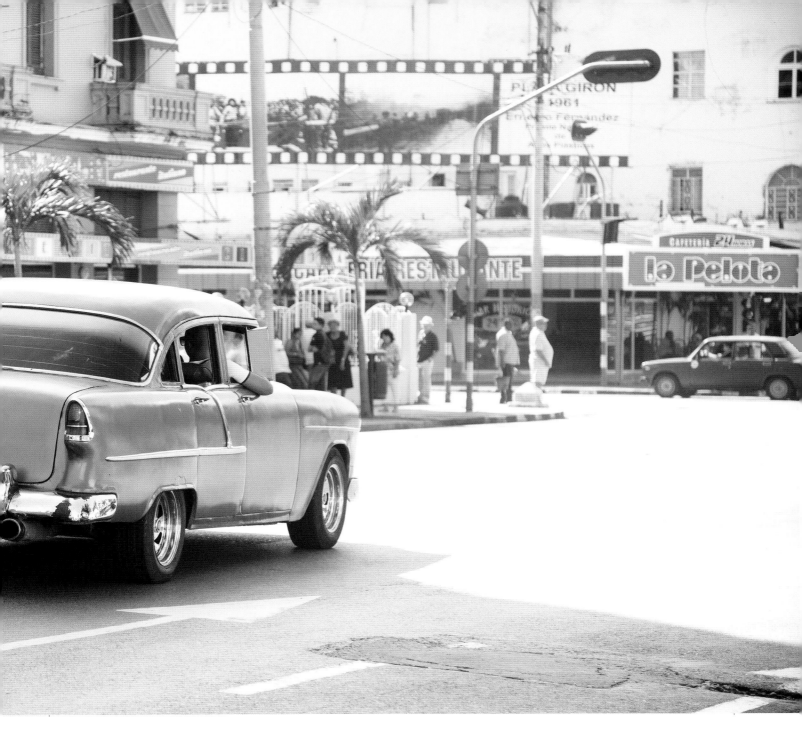

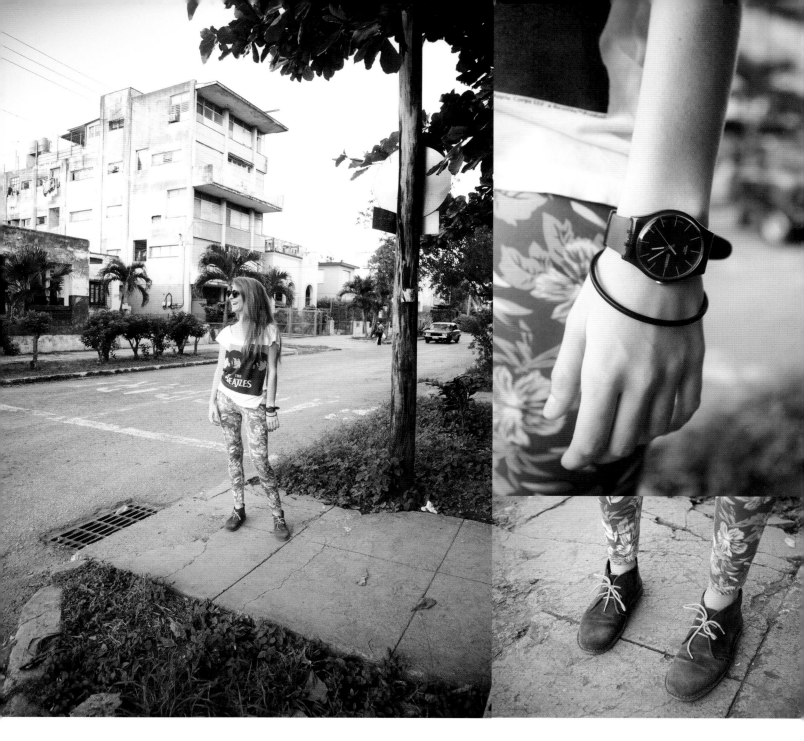

'I just wear things that I feel suit me and make me feel good.'

— JUAN DAVID

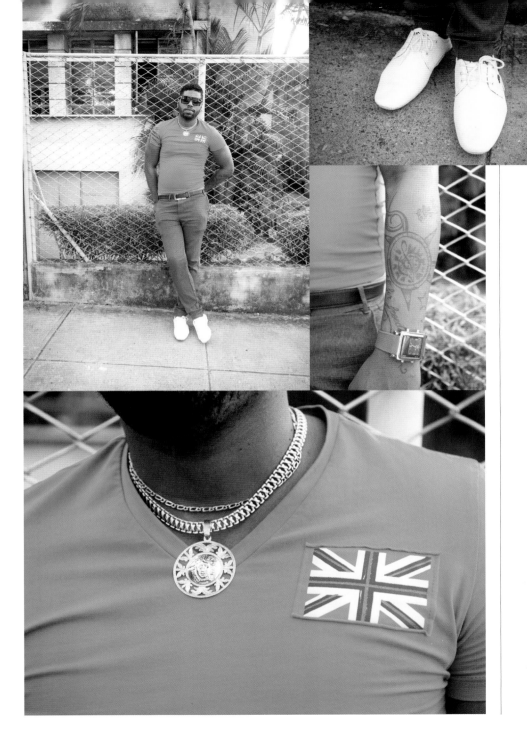

**Sandra (22)**
Graphic designer

**Juan David (22)** →
Cook

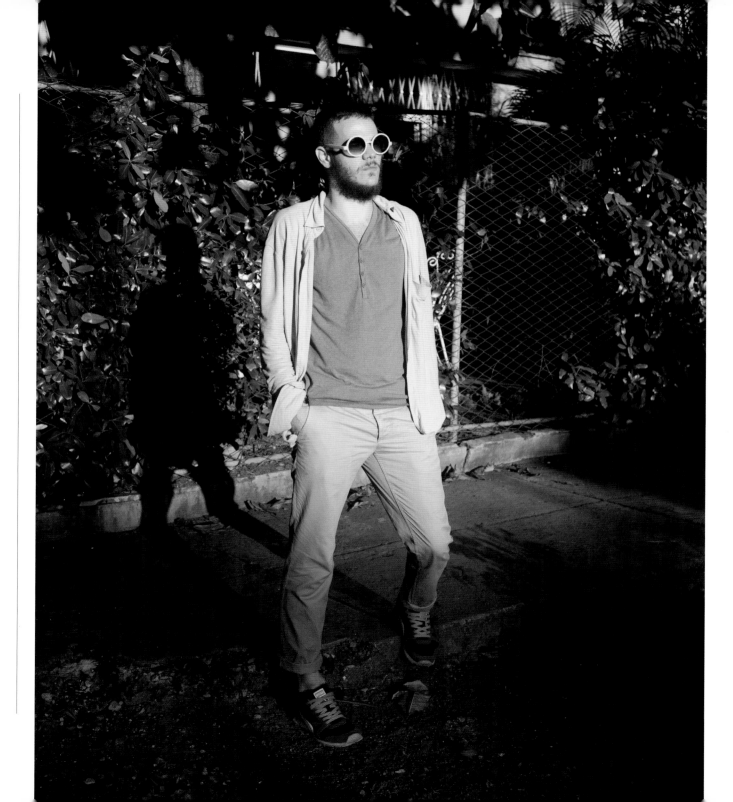

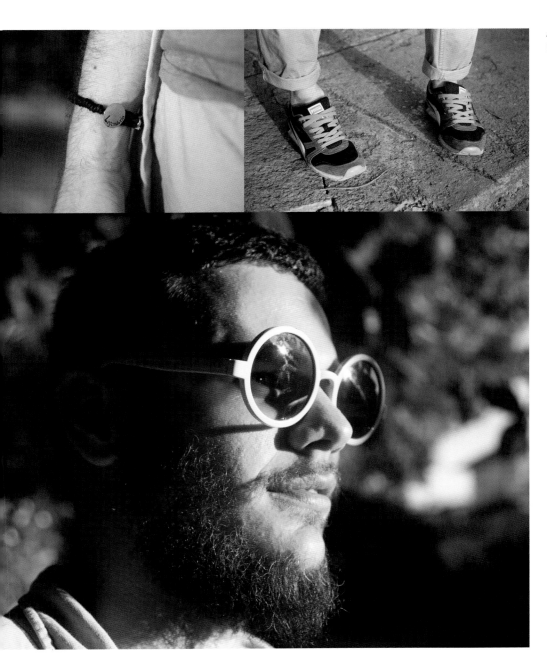

**Alejandro (22)**
Dancer

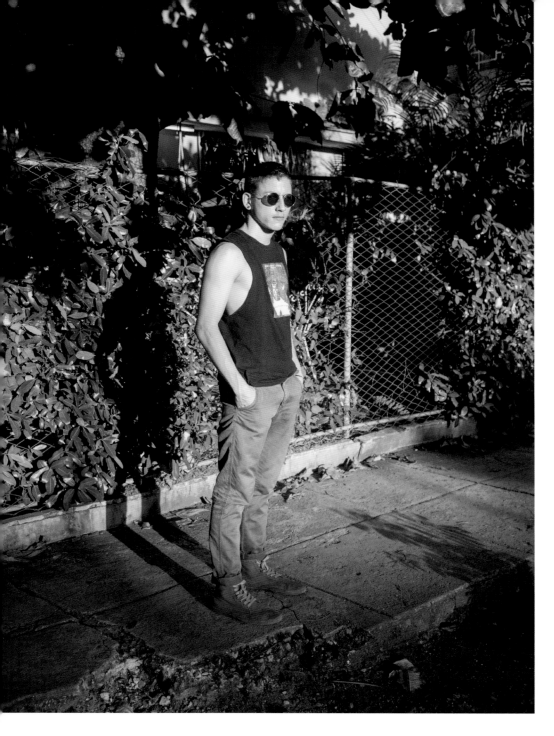

**Maurice (29)** →
Student

**Luis Enrique (21)**
Dancer

**Describe your style.**
I don't know, It's a mix of things.
I like styles from the past, from
specific groups of people and I mix it
in a way that suits me. I don't think
about what I'm going to wear, but I
mix all the things I like.

**Do you have any fashion idols?**
I don't know, mmmm... I like many
brands and I also like people, but
above all, from the music world,
rock singers are the ones I probably
identify with most.

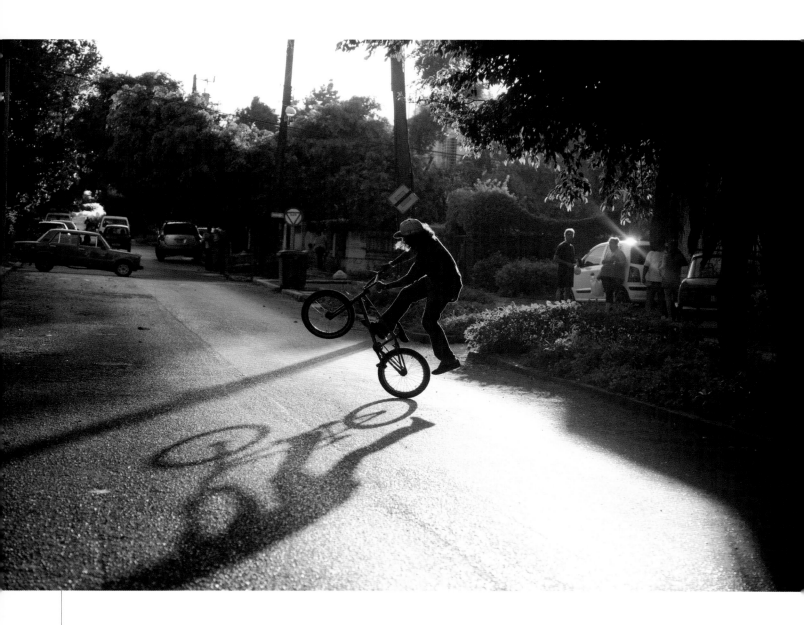

**Rodney (32)**
DJ/BMX stunt rider

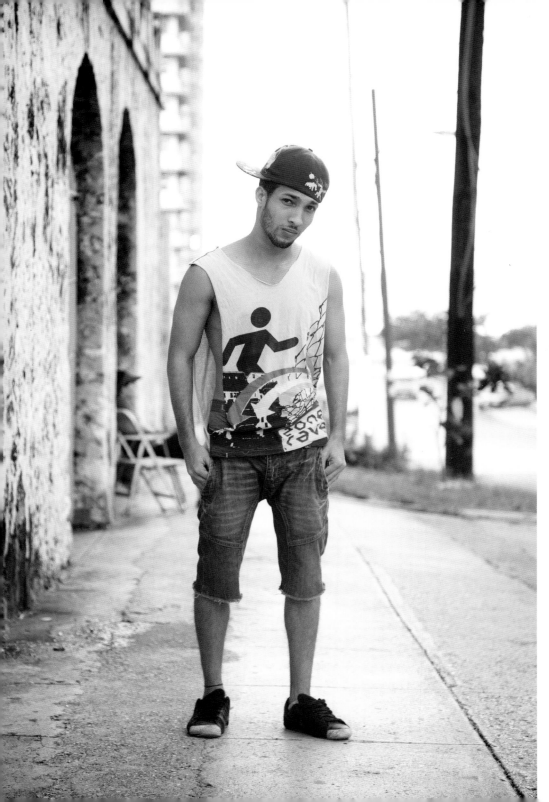

### Alair (32)
Biophysics student

**How do you define your style?**
My style is punk (punkie), it's my crazy way to get attention. My clothes are like mostly inspired by hip pop. Sometimes I change my style to classic, with classic "puntifinos" (oxford shoes and narrow pants) and satin shirts and a vest, in a simple way, not extravagant at all.

### Joagch (26) →
Artist and model

**How do you define your style?**
I don't have a particular style, it depends on my mood when I get up, depending on how I feel that day, I grab what I think looks good, or I wear flip-flops. I don't have a specific way...

**Do you have a style icon?**
No, like I said, some days I feel like I'll wear something more classic, prettier clothes, I don't know, sport clothes, it all depends of how I feel that day.

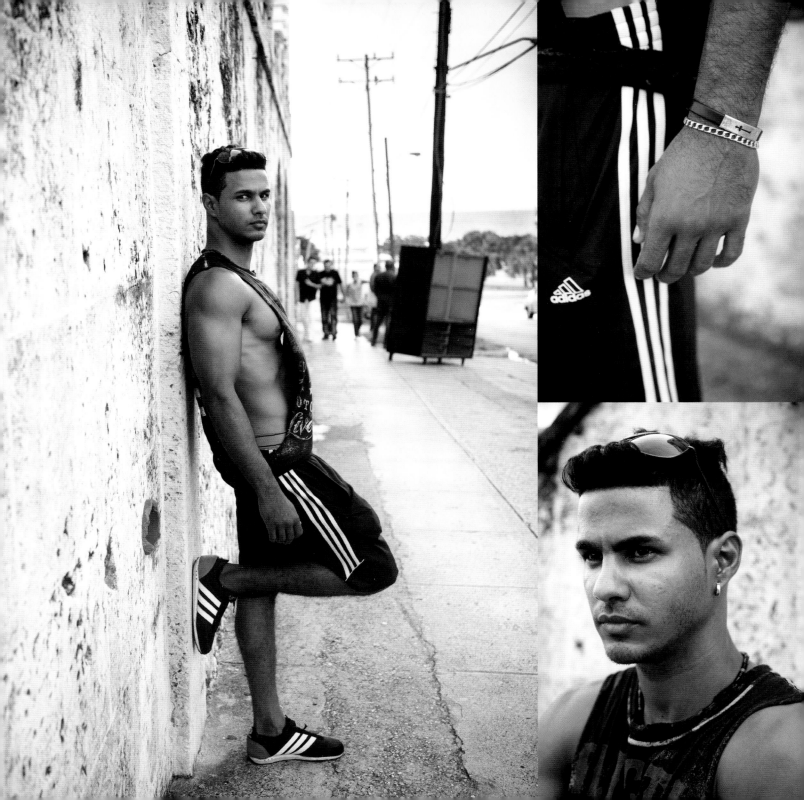

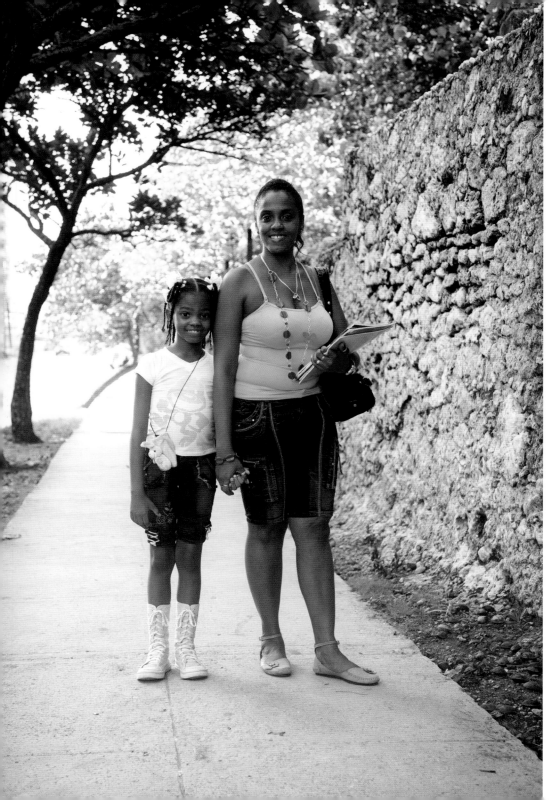

**Janet (38) & Helen (8)**
Restoration artist (& daughter)

**Yennia (25) →**
Musician

**How do you define your style?**
I dress casual, very simple during the day and very elegant at night.

**Do you have favorite brands?**
I like Italian designers like Giorgio Armani and Dolce & Gabbana.

**Do you have a fashion idol?**
I like Angelina Jolie, the way she dresses and how she acts. She has real elegance and style.

**Where do you buy your clothes?**
All these clothes are from here in Havana, but I have clothes from other places, the bag is from Slovenia. I bought it in Slovenia.

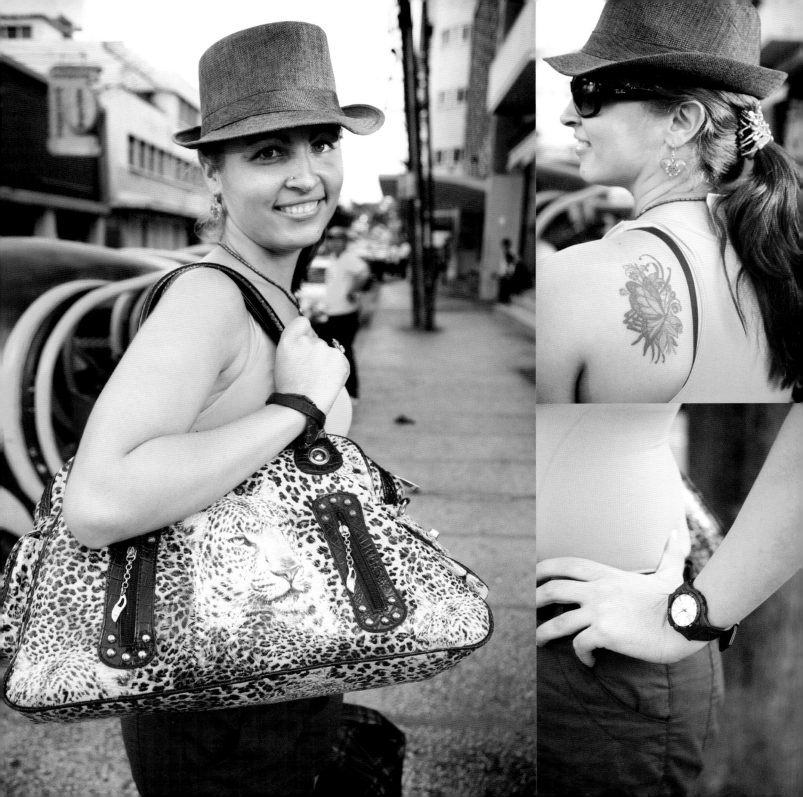

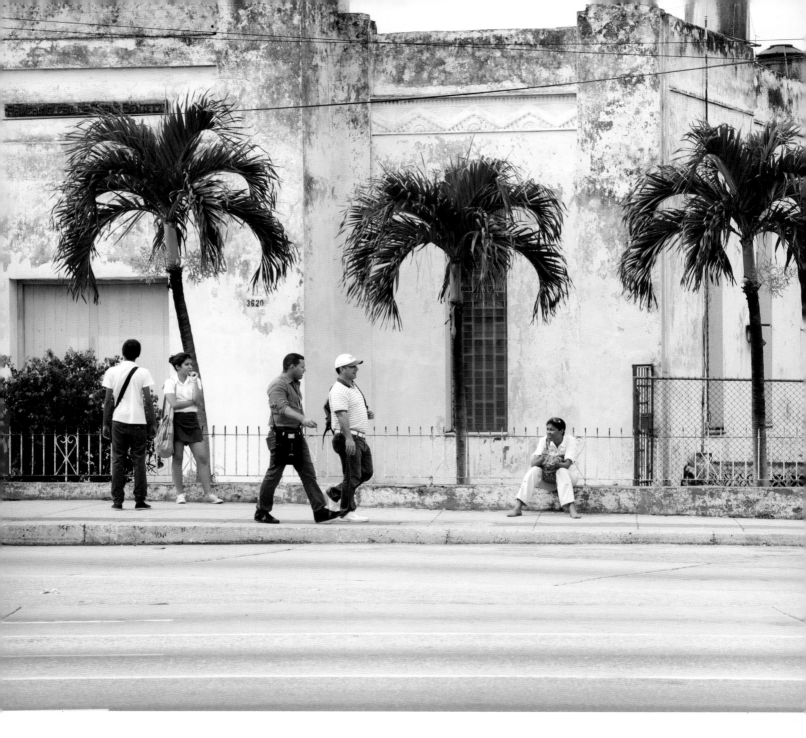

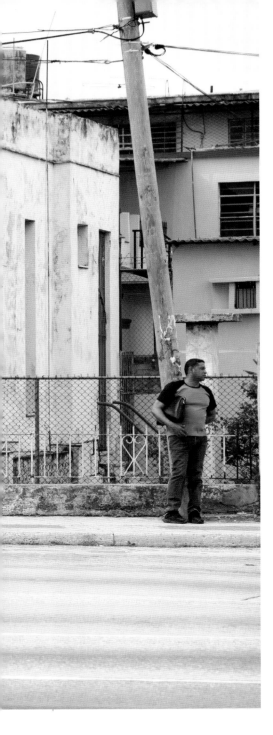

# Playa and Miramar

Considered some of the most desirable real estate in all of Havana, this sprawling municipality is known for its upscale shopping, dining, and housing. Crossing into this section of town via one of two tunnels plunging beneath the Río Almendares or the two bridges which connect this neighborhood to Vedado, is like entering another world. Indeed, Miramar's emblematic 5th Avenue is nicknamed 'embassy row' for all the gorgeous mansions now housing consulates, diplomatic missions, and ambassadorial residences. Sprawling lawns, home security systems – even 24-hour guards – and two-car garages are de rigueur in these parts. Miramar is also Havana's major business district, anchored by the swank Meliá Habana Hotel and the Miramar Trade Center where *habaneros* come to work, shop, and party.

But this doesn't tell the entire story, since Playa (of which Miramar forms a part), also has its share of overcrowded, dilapidated housing and single-room occupancy dwellings known in Cuba as 'solares.' This is a result of haphazard urban planning following the triumph of the revolution and the impossibility for many families to keep up or improve their homes – it's just too difficult to procure proper building materials, not to mention out of financial reach. Most visitors see only the lovely parts of Playa, where grand houses are being restored, their sprawling grounds transformed with elaborate landscaping. Take a scenic drive along 7ma Avenida or the aforementioned 5th Avenue (5ta Avenida) for this perspective. But pick your way along the potholed interior streets bordered by Avenidas 19 and 31 and you'll become acquainted with an entirely different face of this area.

For many visitors, these neighborhoods are considered too sleepy or removed from the city's real action in Vedado, along the Malecón or in Habana Vieja. Nevertheless, Playa, and especially Miramar, is being transformed under Cuba's new economic regulations. These days, night owls can hop between chic lounges, swinging jazz clubs, and sophisticated, VIP-only bars where a drink will costs a good portion of the average state monthly salary. It's wonderful for those with the means to access the rarified air of this emerging scene, a tease and a pipe dream for the rest.

One of the greatest revelations vis-à-vis Havana fashion is seeing how it transforms from day to night, turning from practical and professional to seductive, as the sun drops below the horizon. Miramar, with its combination of office buildings and bars, embassies and lounges, is the best part of town to see how styles morph as the hour grows later. By day, you'll see lots of linen and comfortable shoes, but at night, this gives way to see-through blouses, tight, pegged jeans, and shoes that clearly were not meant for walking. One functional fashion item that never goes out of style – in this or any Havana neighborhood – is the hand fan; you'll even see men trying to cool down using this age-old accessory.

'I really like Christina Aguilerra's style alot. I wanted to be a singer when I was little.'

— BRIGITTE

**Brigitte (17)**
Engineering student

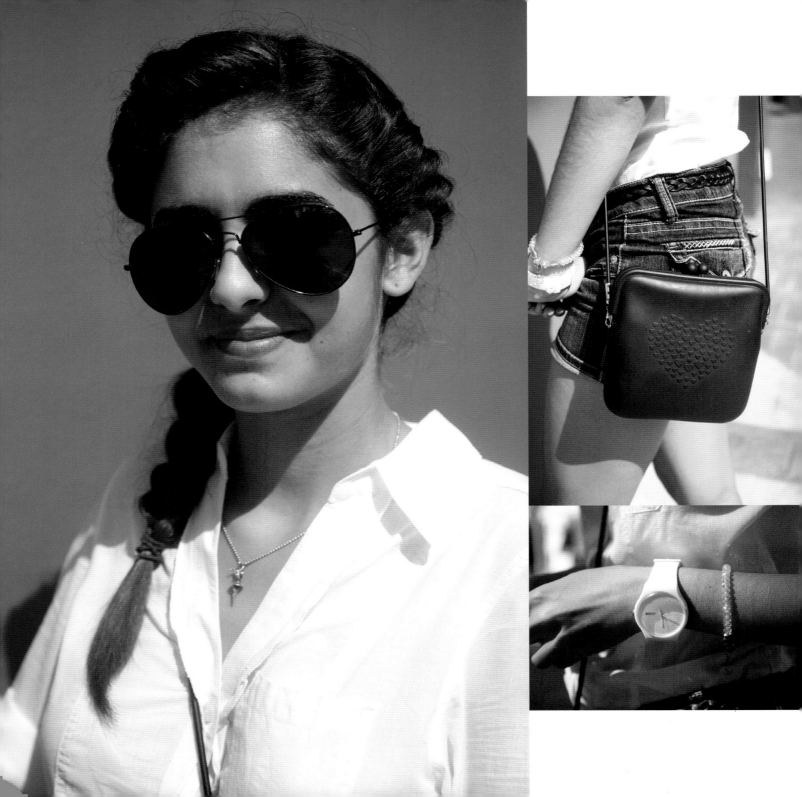

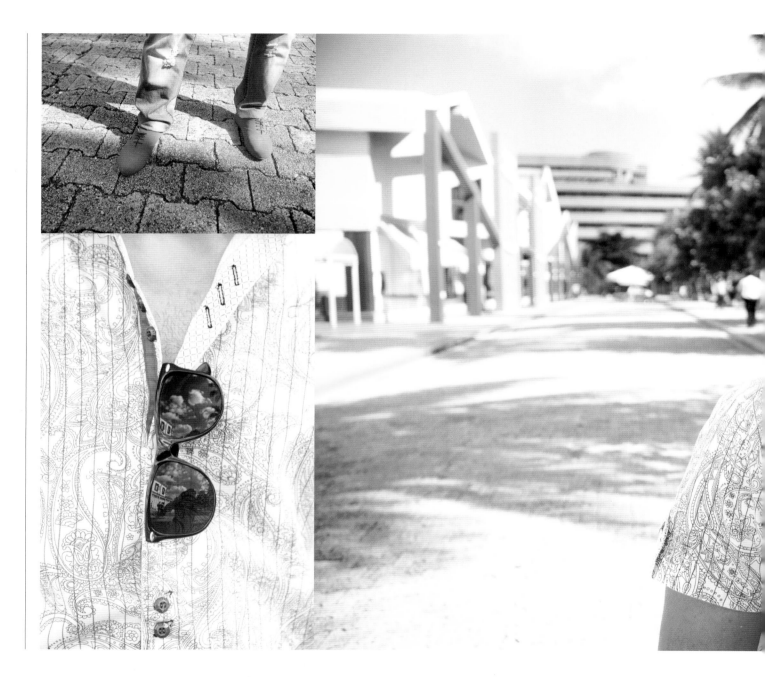

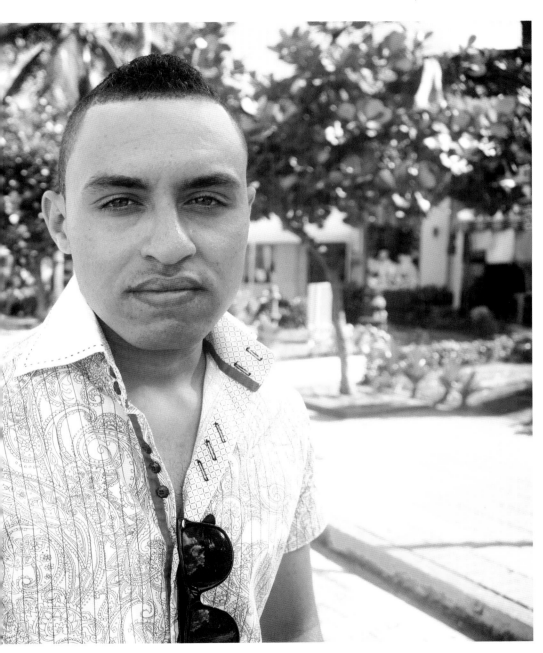

## Luis Alberto (23)

Fashion store employee

**What is your occupation?**

I work at a company called Moda Baila (Fashion Dances), which is a modeling and dance agency. I spend my time cooking and travelling.

**How would you describe your style?**

I like to dress in the fashion of the moment. It depends on where I go and the occasion. If I have to wear casual clothes, I wear casual clothes. If I go to important places, I wear a more traditional shirt, so I adapt to the fashion of the moment, but not in the tacky way that you see alot of today in Cuba. It's varied and it changes a lot.

**Do you have any fashion idols?**

Well, My favorite music idol is Daddy Yankee who dresses well all the time. If he has to appear on the red carpet, he wears a suit, if in a concert he dresses casual. I love his use of t-shirts and hats.

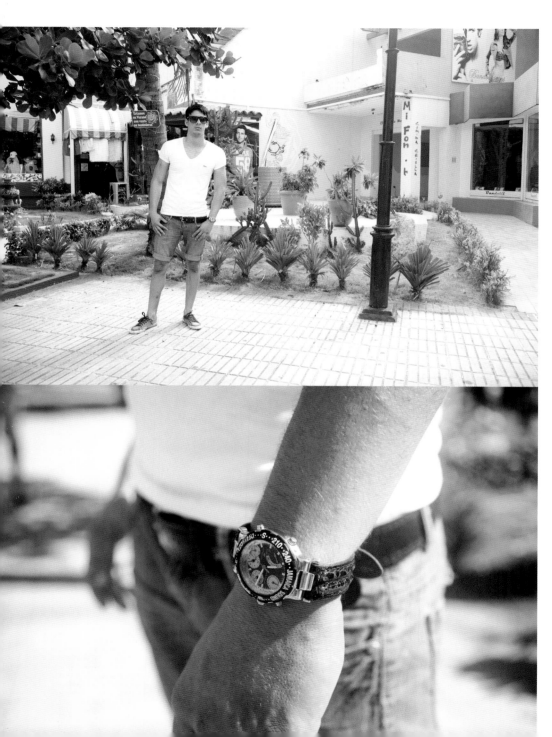

**Ettian (18)**
Caterer

**Liettel (25) →**
Economics student

### How do you describe your style?

In truth it depends on the occasion. I like loose clothes, comfortable. I like white, black and red clothes. Those colors that have more to do with my skin tone. If it's an elegant occasion I will wear a dress, a long dress preferably, any color, it doesn't matter, print dresses are in fashion now, with colors, but because I'm going to a job interview I dress like this, in black combinations which make me feel elegant but professional.

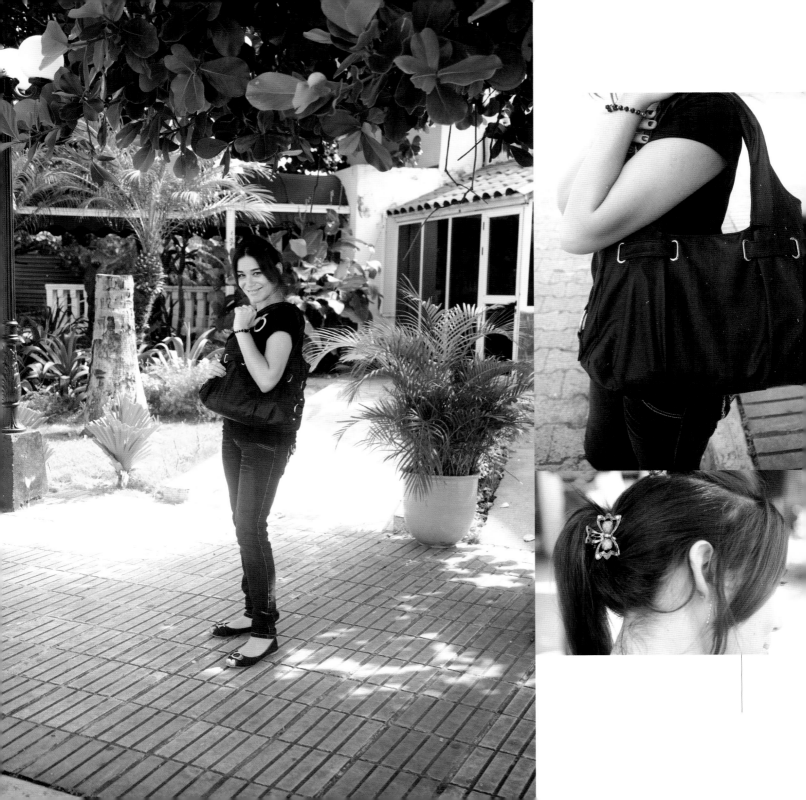

### Mireylio (26)
Student

**Name and occupation?**

My name is Mireiles Manso González Torres, I am from the Isla de la Juventud (Isle of Youth) and I study Agricultural Engineering at the Lista San José.

**Describe your style.**

Well, fashion means different types of style. I personally like more my own, what I like is what I wear. I don't follow any specific fashion, I'd like to use "drelo" or "pendruke" or "laseado". I like to dress "migui" and I also like "de salón" (formal). This is a hot country so you can't wear scarves. That style of scarves I don't like. I like sandals.

**Do you have a style icon?**

I am fan of Beyonce. I like her style - how she dresses, how she walks. I love her shoes, her hair, all of it. Beyonce and Jennifer Lopez. I think Jennifer Lopez also dresses very elegantly. There are others but those two are the ones that captivate me.

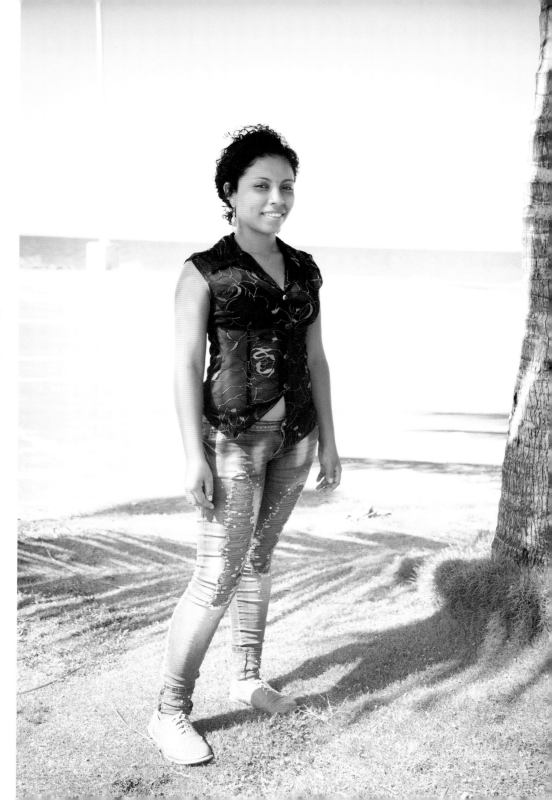

**Eduardo (21)**
Professional chef

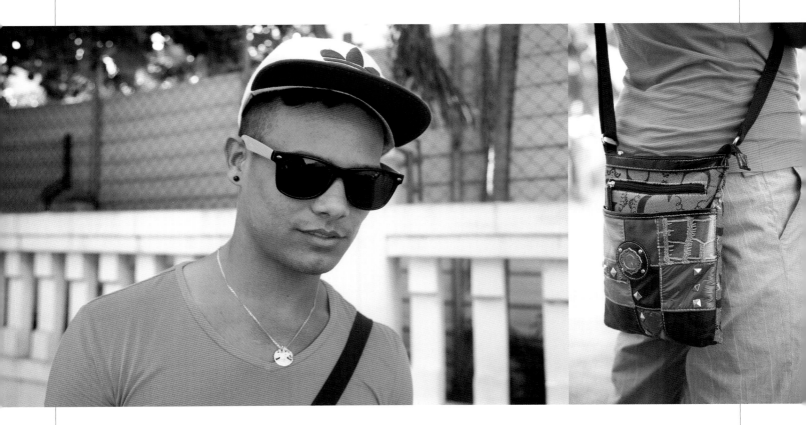

### Luis (37)
Computer technician

**How do you describe
your style?**
Well, this shirt I'm wearing today is a
polo shirt. I dress a lot in gray or beige,
a lot of gray, no black at all, white
sometimes. I like to dress in a simple
way, but good simple brands.

**What brands?**
I like Bass, I like Energy, Sebago, Nike,
strong but simple brands.

**Do you have a style icon?**
No, I don't have anybody. I dress like
this because I like to dress this way, I
don't trust anybody. Well where I live
people don't dress in a masculine way.
I dress in a different way so that I can
go anywhere; simple fashions, any way
I want, classic, and I can use it next
year. If I buy a pair of classic pants like
this, I can use them next year and the
year after, and the next. You have to
make things last here in Cuba.

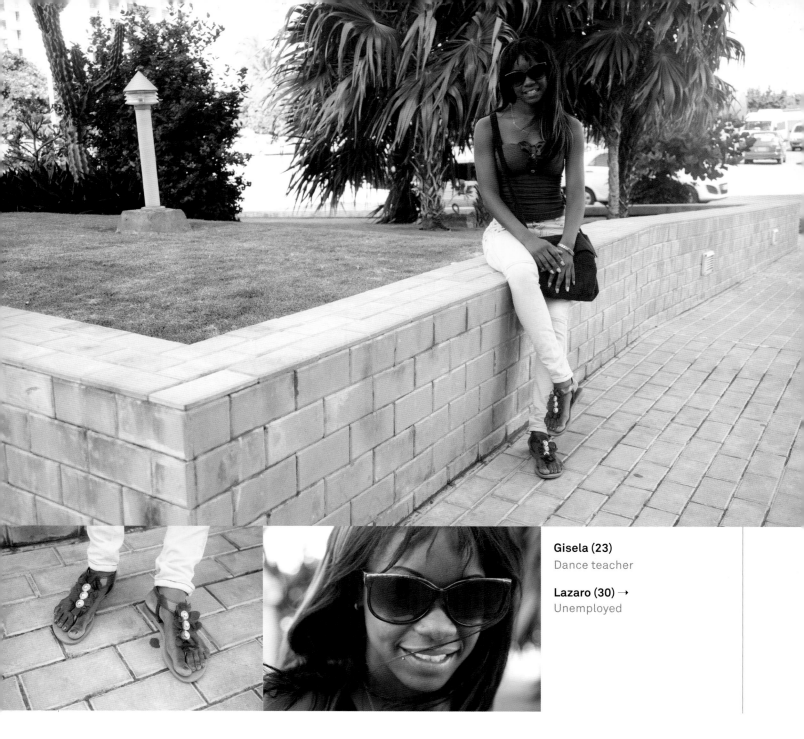

**Gisela (23)**
Dance teacher

**Lazaro (30) →**
Unemployed

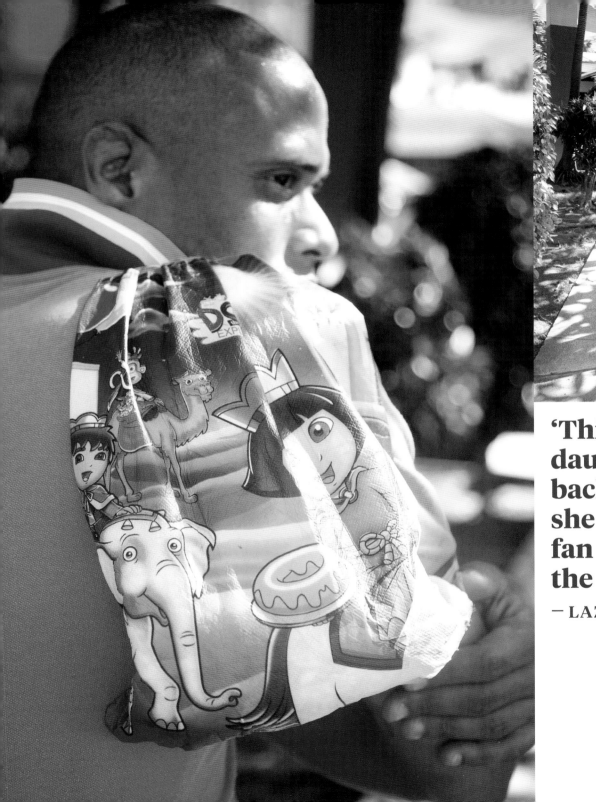

'This is my daughter's backpack - she is a big fan of Dora the Explorer.'

— LAZARO

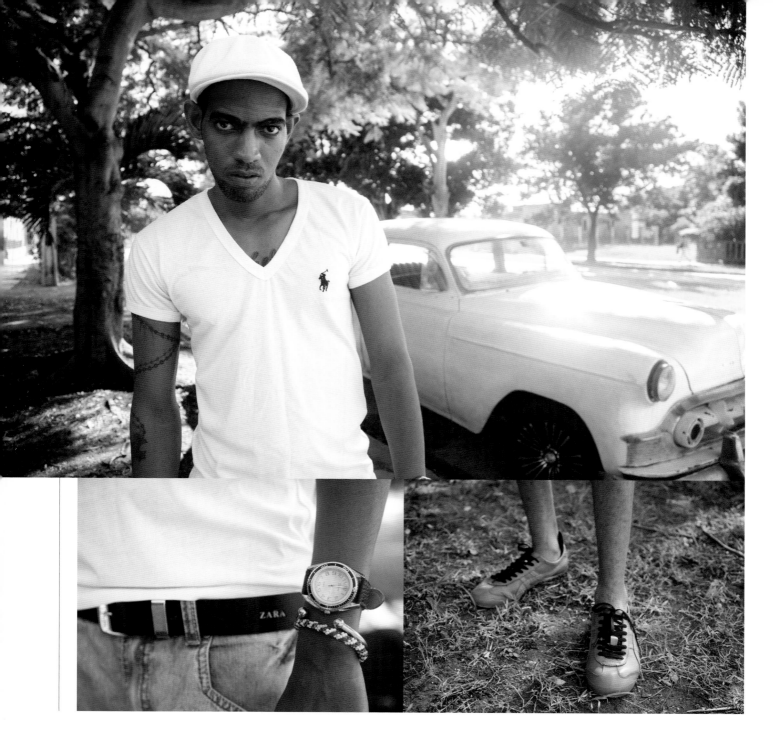

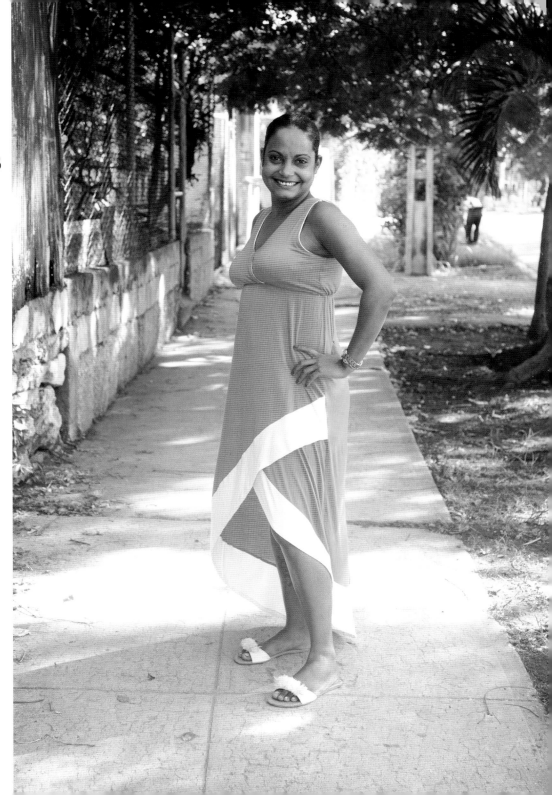

'I am not very extravagant, but sometimes I get dressed up to show what I've got!'

— TAMARA

**Michel Garcia (22)**
Baker

**Tamara Venereo (29)** →
Actress

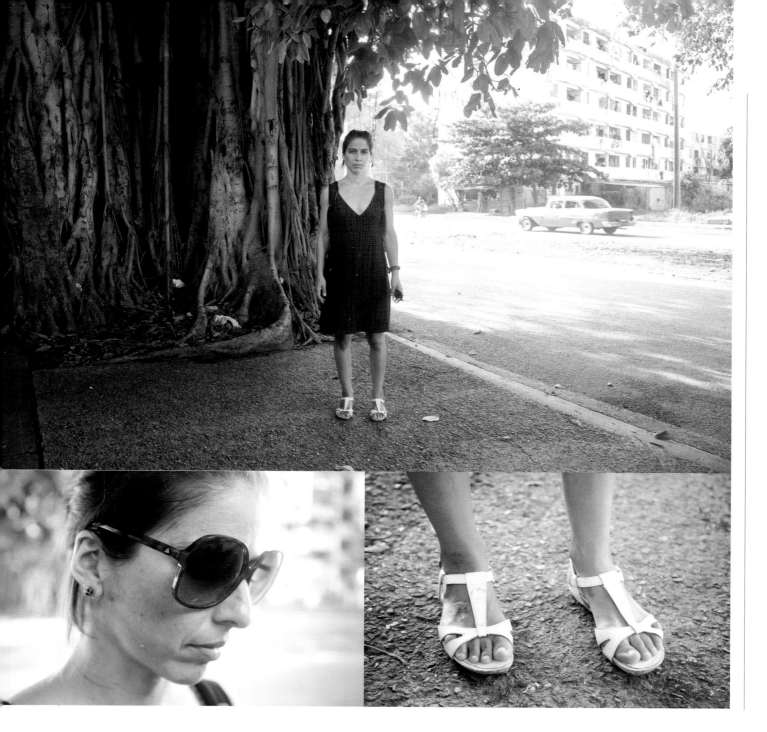

**Eleanor (24)**
Actress

**Arai Margarita (37) →**
Dancer

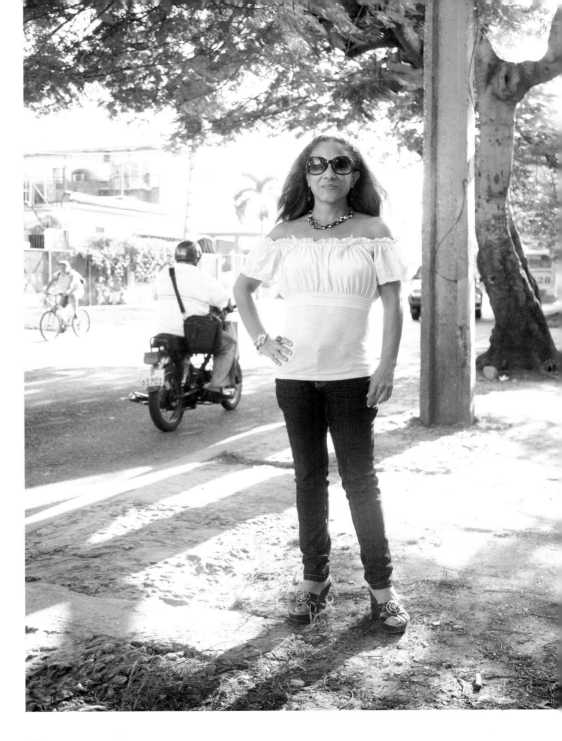

'My style is like, I don't know how to say... rasta? and Lil' Wayne style because he's my favourite singer.'

— YOSLANDY

**Yoslandy Calzada (25)**
Park keeper

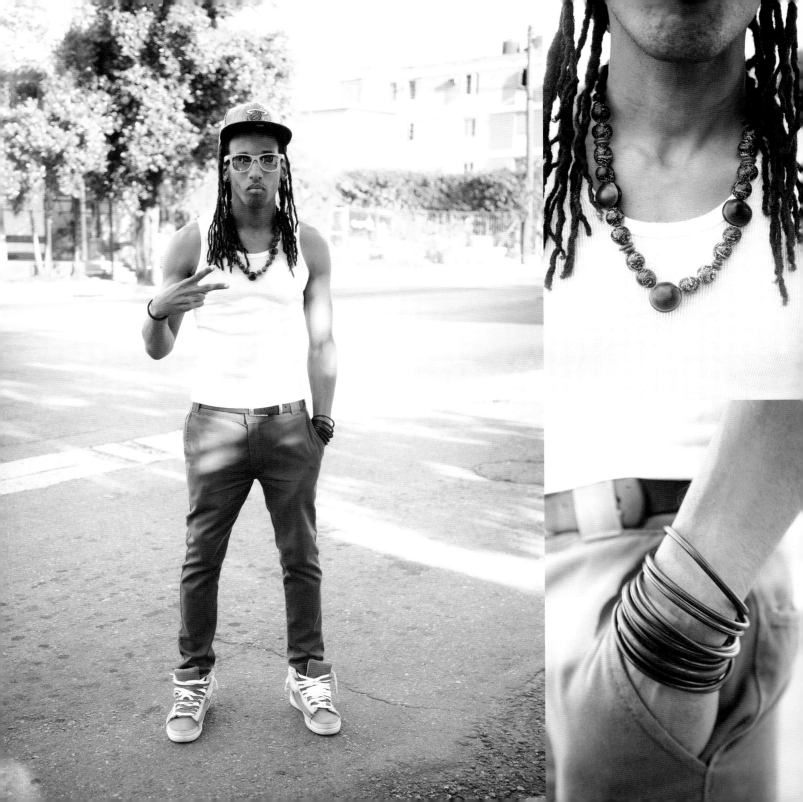

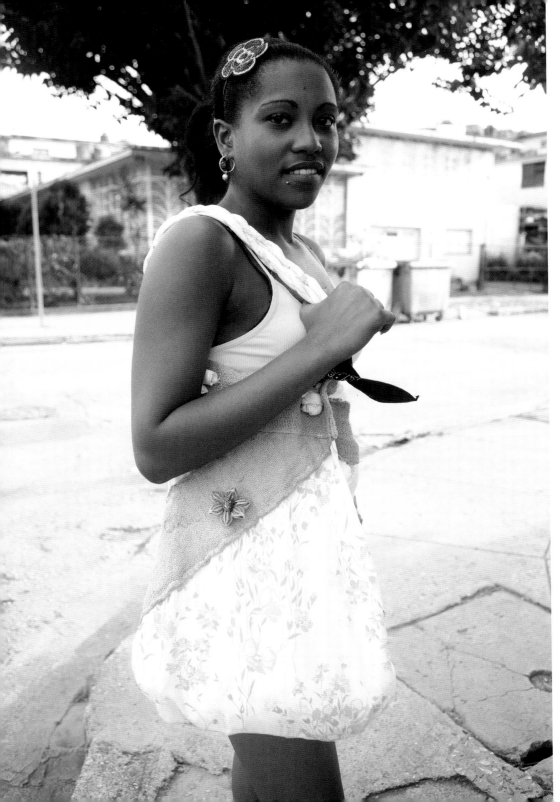

## Yemi Castro (18)
Student

### How would you describe your style?
Well, I like the way Beyonce dresses. The fashion I use is like hers; "en chu" in pants, shawls... sayas, Cuban fashions. I always like dressing in different colors which have some relation to each other.

### Can you talk a bit about your fingernails?
Cuban women paint their nails to make them look special. There are so many possibilities; colours, patterns and designs that allow you to be creative. This glittery blue varnish is my favourite.

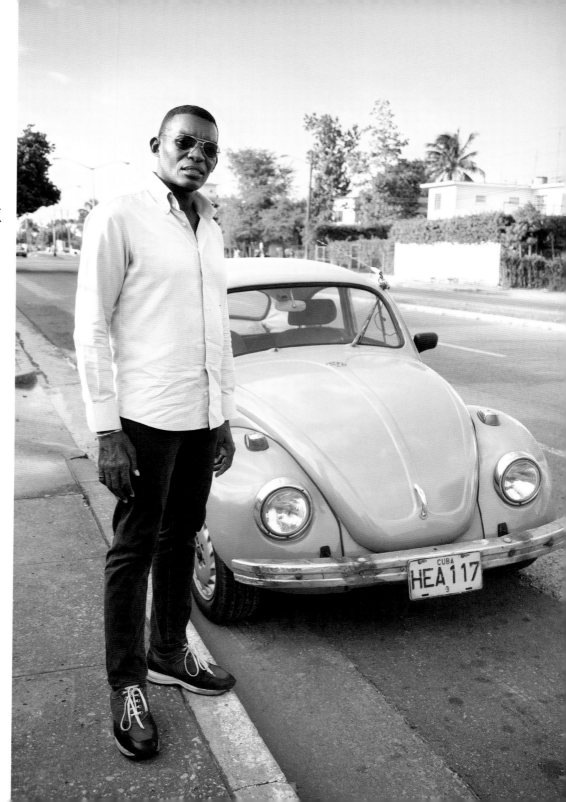

'I get lots
of clothes
from Italy
so people
tend to think
I'm very
fashionable.'

— ALBERT

**Albert Ajar (48)**
Radiologist

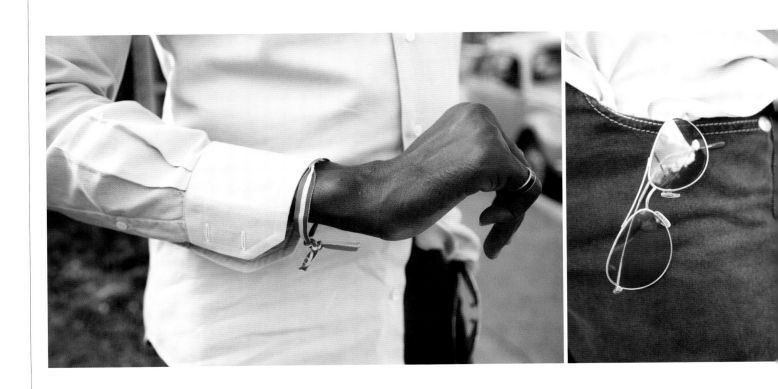

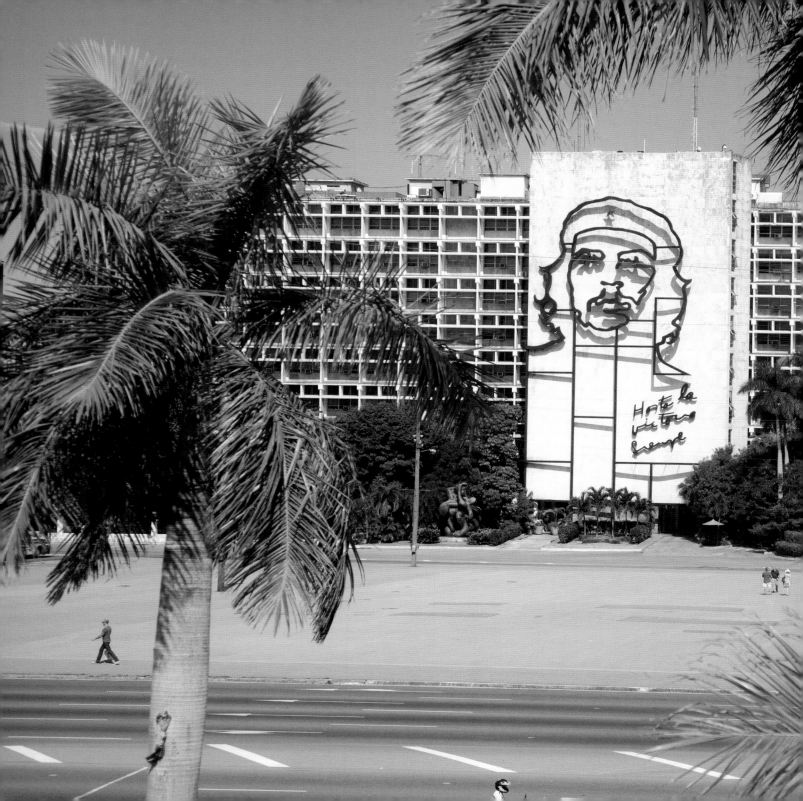

# About the Authors

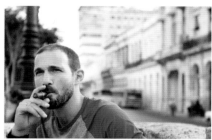

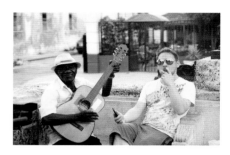

### Conner Gorry

A native New Yorker, Conner first traveled to Cuba in 1993 and has been based in Havana since 2002 where she reports on Cuban health and medicine for MEDICC Review. Her work on Cuba has been published by NY Magazine, Scientific American, BBC, and the Irish Times, among others. She is a contributor to several anthologies including Best Travel Writing 2012 and A Contemporary Cuba Reader (2014). Conner is also the brainchild behind Cuba's first English-language bookstore and café, Cuba Libro. She writes about Cuban fashion and other island peculiarities at her blog *www.hereishavana.com.*
Visiting Cuba? Check out her app 'Havana Good Time' (for iOS and Android).
*www.connergorry.com*
photo: Kristen McQueen

### Gabriel Solomons

Gabriel is both a practicing graphic designer and senior lecturer at the Bristol School of Creative Arts. Alongside working with design clients, he has been responsible for developing a number of trade publications that cover areas of film, design, fandom and fashion – all of which aim to further our understanding of collaborative practice and explore the wider influence of creativity in society. His edited publications include *World Film Locations: Los Angeles* and *World Film Locations: Rome* and he is currently innovation manager and book series editor at Intellect.
photo:Martin Tompkins

### Martin Tompkins

Martin is a photographer and video producer based in the South West of England. His time is currently split between producing promotional music videos and portrait photography. His work has taken him to Europe and America, working for publications including, The Italian Magazine, Decode Magazine and Bath Life. Solo exhibitions include, 'Everything In Between - a journey into the American Heartland' (exhibition and book), 'Wall of Sound' - portraits of musicians and 'The Twin Towns of Bath' - a study of the town and people of Kaposvár, Hungary.
*www.martintompkins.com*
photo: Gabriel Solomons

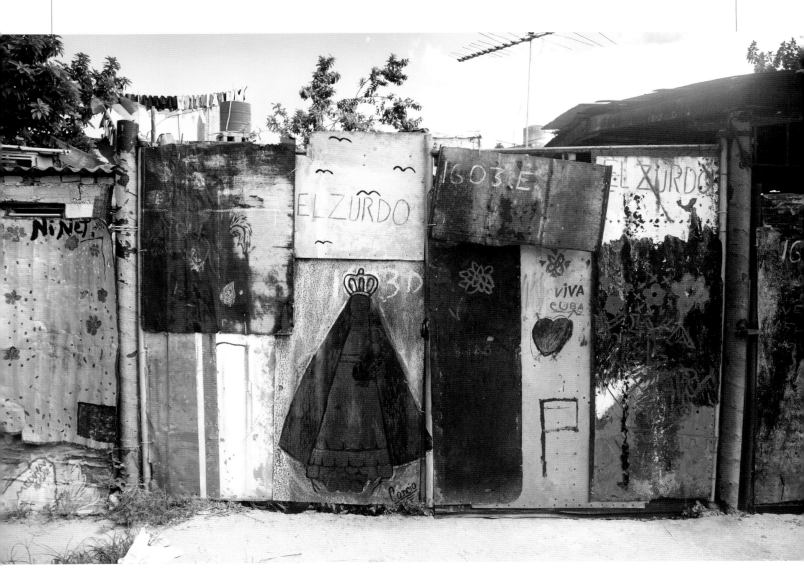

**Men at work**
Vedado

For further information about
the Street Style series of books
published by Intellect, visit:
**www.streetstyleseries.com**